PARKETT BOOKS

A LARGE LIBRARY
AND A SMALL MUSEUM
ON CONTEMPORARY ART

Dear Reader, dear Subscriber,

We welcome you to the most comprehensive book series on contemporary artists. Parkett does not report on art from the outside in; Parkett discovers art from the inside out. Each volume focuses on several of the world's most compelling and inspiring artists, who actively collaborate in creating the publication down to the selection of the visuals and the page layout.

Parkett's backlist features some 60 titles with a total of 200 artists' collaborations and 900 texts by renowned authors, which cover each artist's work with several in-depth articles. Additional insight into contemporary art is presented in a playful series of rubrics such as Cumulus, Insert, Balkon, and Les Infos du Paradis. Each new volume is published in high quality book design with over 200 pages and 200 color reproductions.

The Set of all 60 available Parkett volumes, a unique, comprehensive library on contemporary art, is now available with a special offer, see p. 10.

Each collaborating artist also creates a limited edition in the form of a print, photograph, object, or installation exclusively for Parkett. More information on these artists' editions is available at the back of this brochure and in the catalogue raisonné "200 Artworks – 25 Years".

If you have any questions or wish to order Parkett books, please contact Parkett in Zurich or New York at info@parkettart.com or your bookshop resp. the book distributor nearest you. We will gladly also help you find out-of-print volumes. More information on Parkett books is also available at www.parkettart.com.

Sincerely,

Dieter von Graffenried
Publisher

Bice Curiger
Editor-in-Chief

PS
For alphabetical and chronological lists of all artists and Parkett volumes see p. 26 resp 28.

Parkett spines / Parkett Buchrücken

«Ein Katalysator für inspirierende Veränderungen und zugleich ‹die Ernte des ruhigen Auges›».

Hans Ulrich Obrist

Liebe Leserin, lieber Leser, liebe Abonnenten,

Wir begrüssen Sie herzlich bei der umfassendsten Buchreihe über Gegenwartskünstlerinnen und -künstler.

Parkett berichtet nicht über Künstlerinnen oder Künstler, sondern entsteht in direkter Zusammenarbeit mit ihnen. Mehrere der gegenwärtig inspirierendsten und interessantesten Künstler stehen im Mittelpunkt jeder Ausgabe. Sie arbeiten an den Beiträgen aktiv mit – einschliesslich Bildauswahl und Seitengestaltung.

Über 60 lieferbare Titel bieten Ihnen 200 monographische Künstler-Collaborations mit insgesamt 900 ausführlichen Texten von führenden Autoren. Zusätzliche Informationen zur Gegenwartskunst finden sich in einer spielerischen Palette von Rubriken wie Insert, Cumulus, Balkon oder Les Infos du Paradis. Jeder neue Band erscheint in herausragender Buchgestaltung mit über 200 Seiten und 200 Farbabbildungen.

Der Set aller 60 erhältlichen Bände ist gegenwärtig zu einem Sonderangebot erhältlich, siehe dazu die Detailinformationen auf S. 11.

Jeder Collaboration-Künstler schafft zudem eigens für Parkett eine signierte und limitierte Edition in Form einer Druckgraphik, einer Photographie, eines Objektes oder einer Installation. Diese Künstlereditionen sind umfassend im Werkkatalog «200 Artworks – 25 Years» dokumentiert.

Ihre Fragen oder Bestellungen können Sie direkt an Parkett in Zürich oder New York (info@parkettart.com) oder an Ihre Buchhandlung bzw. Ihren Buchvertrieb richten. Wir helfen Ihnen auch gerne bei der Suche nach vergriffenen Bänden. Weitere Informationen gibt Ihnen natürlich auch www.parkettart.com.

Mit freundlichen Grüssen,

Dieter von Graffenried
Verleger

Bice Curiger
Chefredakteurin

PS
Für die alphabetische und chronologische Übersicht aller Künstler bzw. Parkett-Bände siehe S. 26 bzw. S. 28.

Parkett Verlag
Quellenstrasse 27
CH-8031 Zürich
phone +41-44-271 8140
fax +41-44-272 4301

Parkett Publishers
145 Ave. of the Americas
New York, NY 10013
phone (212) 673 2660
fax (212) 271 0704

www.parkettart.com
info@parkettart.com

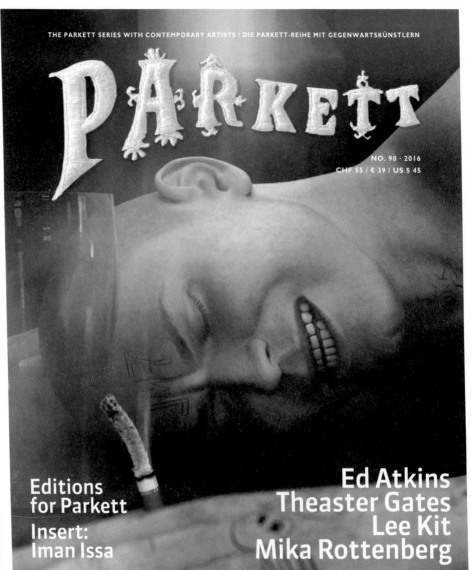

THE PARKETT SERIES WITH CONTEMPORARY ARTISTS / DIE PARKETT-REIHE MIT GEGENWARTSKÜNSTLERN

PARKETT

NO. 98 · 2016
CHF 55 / € 39 / US $ 45

Editions
for Parkett

Insert:
Iman Issa

Ed Atkins
Theaster Gates
Lee Kit
Mika Rottenberg

Cover: Ed Atkins

NO. 98 – COLLABORATIONS
ED ATKINS
THEASTER GATES
LEE KIT
MIKA ROTTENBERG

276 p, ca. 200 illus.
ISBN 978-3-907582-58-9

Cover: Camille Henrot

276 p. ca. 200 illus.
ISBN 978-3-907582-57-2

NO. 97 – COLLABORATIONS
ANDREA BÜTTNER
ABRAHAM CRUZVILLEGAS
CAMILLE HENROT
HITO STEYERL

Cover: Pamela Rosenkranz

270 p. ca. 180 illus.
ISBN 978-3-907582-56-5

NO. 96 – COLLABORATIONS
MARC CAMILLE CHAIMOWICZ
PAMELA ROSENKRANZ
JOHN WATERS
XU ZHEN

Cover: Rosemarie Trockel

300 p. ca. 180 illus.
ISBN 978-3-907582-55-8

NO. 95 – COLLABORATIONS
JEREMY DELLER
WAEL SHAWKY
DAYANITA SINGH
ROSEMARIE TROCKEL

Cover: Shirana Shahbazi

300 p. ca. 180 illus.
ISBN 978-3-907582-54-1

NO. 94 – COLLABORATIONS
TAUBA AUERBACH
URS FISCHER
CYPRIEN GAILLARD
RAGNAR KJARTANSSON
SHIRANA SHAHBAZI

Cover: Danh Vo

288 p. ca. 180 illus.
ISBN 978-3-907582-53-4

NO. 93 – COLLABORATIONS
VALENTIN CARRON
FRANCES STARK
ADRIÁN VILLAR ROJAS
DANH VO

Cover: Damián Ortega

288 p. ca. 180 illus.
ISBN 978-3-907582-52-7

NO. 92 – COLLABORATIONS
JIMMIE DURHAM
HELEN MARTEN
PAULINA OLOWSKA
DAMIÁN ORTEGA

Cover: Liu Xiadong

260 p., ca. 180 illus.
ISBN 978-3-907582-51-0

NO. 91 – COLLABORATIONS
YTO BARRADA
NICOLE EISENMAN
LIU XIAODONG
MONIKA SOSNOWSKA

Cover: Nathalie Djurberg

260 p., ca. 180 illus.
ISBN 978-3-907582-50-3

NO. 90 – COLLABORATIONS
EL ANATSUI
NATHALIE DJURBERG
RASHID JOHNSON
R. H. QUAYTMAN

Cover: Mark Bradford

260 p., ca. 180 illus.
ISBN 978-3-907582-49-7

NO. 89 – COLLABORATIONS
MARK BRADFORD
CHARLINE VON HEYL
OSCAR TUAZON
HAEGUE YANG

Cover: Kerstin Brätsch

240 p., ca. 180 illus.
ISBN 978-3-907582-48-0

NO. 88 – COLLABORATIONS
KERSTIN BRÄTSCH
PAUL CHAN
STURTEVANT
ANDRO WEKUA

Cover: Katharina Fritsch

225 p., ca. 150 illus.
ISBN 978-3-907582-47-3

NO. 87 – COLLABORATIONS
ANNETTE KELM
KELLEY WALKER
CERITH WYN EVANS

SPECIAL 25 YEARS
COLLABORATION:
KATHARINA FRITSCH

Cover: John Baldessari

225 p., ca. 150 illus.
ISBN 978-3-907582-46-6

NO. 86 – COLLABORATIONS
CAROL BOVE
PHILIPPE PARRENO
JOSIAH MCELHENY

SPECIAL 25 YEARS
COLLABORATION:
JOHN BALDESSARI

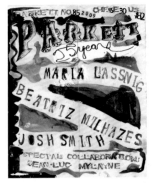

Cover: Josh Smith

253 p., ca. 160 illus.
ISBN 978-3-907582-45-9

NO. 85 – COLLABORATIONS
MARIA LASSNIG
BEATRIZ MILHAZES
JOSH SMITH

SPECIAL 25 YEARS
COLLABORATION:
JEAN-LUC MYLAYNE

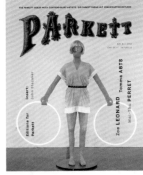

Cover: Mai-Thu Perret

227 p., ca. 150 illus.
ISBN 978-3-907582-44-2

NO. 84 – COLLABORATIONS
TOMMA ABTS
ZOE LEONARD
MAI-THU PERRET

Cover: Wade Guyton / Christopher Wool

235 p., ca. 150 illus.
ISBN 978-3-907582-43-5

NO. 83 – COLLABORATIONS
ROBERT FRANK
WADE GUYTON
CHRISTOPHER WOOL

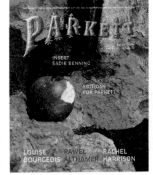

Cover: Rachel Harrison

229 p., ca. 150 illus.
ISBN 978-3-907582-42-8

NO. 82 – COLLABORATIONS
LOUISE BOURGEOIS
PAWEŁ ALTHAMER
RACHEL HARRISON

Cover: Cosima von Bonin

219 p., ca. 150 illus.
ISBN 978-3-907582-41-1

NO. 81 – COLLABORATIONS
COSIMA VON BONIN
CHRISTIAN JANKOWSKI
AI WEIWEI

Cover: Mark Grotjahn

219 p., ca. 150 illus.
ISBN 978-3-907582-40-4

NO. 80 – COLLABORATIONS
ALLORA & CALZADILLA
DOMINIQUE GONZALEZ-
FOERSTER
MARK GROTJAHN

Cover: Marilyn Minter

217 p. ca. 150 illus.
ISBN 978-3-907582-39-8

NO. 79 – COLLABORATIONS
**ALBERT OEHLEN
JON KESSLER
MARILYN MINTER**

Cover: Ernesto Neto

219 p. ca. 150 illus.
ISBN 978-3-907582-38-1

NO. 78 – COLLABORATIONS
**REBECCA WARREN
OLAF NICOLAI
ERNESTO NETO**

Cover: Rudolf Stingel

213 p. ca. 150 illus.
ISBN 978-3-907582-37-4

NO. 77 – COLLABORATIONS
**CARSTEN HÖLLER
TRISHA DONNELLY
RUDOLF STINGEL**

Cover: Yang Fudong

225 p. ca. 150 illus.
ISBN 978-3-907582-36-7

NO. 76 – COLLABORATIONS
**JULIE MEHRETU
YANG FUDONG
LUCY MCKENZIE**

Cover: Glenn Brown

211 p. ca. 150 illus.
ISBN 978-3-907582-35-7

NO. 75 – COLLABORATIONS
**DANA SCHUTZ
KAI ALTHOFF
GLENN BROWN**

Cover: Richard Serra

219 p. ca. 150 illus.
ISBN 978-3-907582-34-3

NO. 74 – COLLABORATIONS
**RICHARD SERRA
BERNARD FRIZE
KATHARINA GROSSE**

Cover: Ellen Gallagher

213 p., ca. 150 illus.
ISBN 978-3-907582-33-6

NO. 73 – COLLABORATIONS
**ELLEN GALLAGHER
ANRI SALA
PAUL McCARTHY**

Cover: Richard Prince

233 p., ca. 160 illus.
ISBN 978-3-907582-32-9

NO. 72 – COLLABORATIONS
**MONICA BONVICINI
URS FISCHER
RICHARD PRINCE**

Cover: Olaf Breuning

233 p., ca. 160 illus.
ISBN 978-3-907582-31-2

NO. 71 – COLLABORATIONS
**OLAF BREUNING
RICHARD PHILLIPS
KEITH TYSON**

Cover: Wilhelm Sasnal

233 p., ca. 150 illus.
ISBN 978-3-907582-20-6

NO. 70 – COLLABORATIONS
**CHRISTIAN MARCLAY
WILHELM SASNAL
GILLIAN WEARING**

Cover: Anish Kapoor

215 p., ca. 140 illus.
ISBN 978-3-907582-19-0

NO. 69 – COLLABORATIONS
**FRANCIS ALŸS
ISA GENZKEN
ANISH KAPOOR**

Cover: Franz Ackermann

217 p., ca. 150 illus.
ISBN 978-3-907582-18-3

NO. 68 – COLLABORATIONS
**FRANZ ACKERMANN
EIJA-LIISA AHTILA
DAN GRAHAM**

COMPLETE YOUR PARKETT LIBRARY

THE SET OF ALL 60 AVAILABLE PARKETT VOLUMES

- 60 fully illustrated volumes on contemporary art (p. 4–18)
- 170 in-depth artist portraits, each with 3–5 texts
- 900 texts and essays by leading authors and writers
- more than 8000 pages and 4000 colour reproductions
- Parkett's signature book design, sewn binding, 10 x 8 ¼"

For price and order information see p. 27.

Cover Vol. 98:
Ed Atkins

"... Parkett hat der Zeit zugleich den Puls genommen und ihr ein Schaulager in Buchform gebaut. Und so Gegenwart in Dauer überführt."
Stanislaus von Moos,
Prof. em. Universität Zürich

VERVOLLSTÄNDIGEN SIE IHRE PARKETT-BIBLIOTHEK

DER SET ALLER 60 ERHÄLTLICHEN PARKETT-BÄNDE

- 60 Einzelbände zur Gegenwartskunst (S. 4–18)
- 170 ausführliche Künstlerportraits mit je 3–5 Texten
- 900 Texte und Essays von führenden Autorinnen und Autoren
- über 8000 Seiten mit 4000 Farbabbildungen
- Parkett's Buch-Design, Fadenheftung, 25,5 x 21 cm

Für Preis- und Bestellinformationen s. hinten S. 27.

Cover Vol. 97:
Camille Henrot

"PARKETT is a catalyst for invigorating change whilst always producing the "harvest of the quiet eye"."
Hans Ulrich Obrist, Co-Director, Serpentine Gallery, London

OUT OF PRINT VOLUMES

Looking for an out-of-print Parkett volume? Increase the content and value of your Parkett Library by adding missing volumes. We may be able to help you find a much sought-after volume. See the cover images below for a selection of currently available out-of-print volumes. For any further information please contact Bozena Civic in Zurich (b.civic@parkettart.com) or Melissa Burgos in New York (m.burgos@parkettart.com). Delivery subject to availability.

NO. 12 ANDY WARHOL, 1987

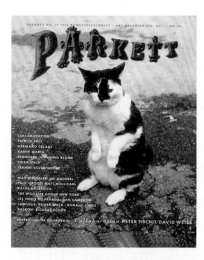

NO. 17 PETER FISCHLI / DAVID WEISS, 1988

NO. 31 DAVID HAMMONS,
MIKE KELLEY, 1992

NO. 33 ROSEMARIE TROCKEL,
CHRISTOPHER WOOL, 1992

VERGRIFFENE EINZELBÄNDE

Suchen Sie seltene, vergriffene Einzelbände zur Komplettierung Ihrer Parkett Bibliothek? Wir können Ihnen gerne beim Finden behilflich sein. Nachfolgend finden Sie Abbildungen der Titelblättern ausgewählter, momentan erhältlicher, vergriffener Einzelbände. Für mehr Informationen zu diesen und weiteren Bänden kontaktieren Sie bitte Bozena Civic (b.civic@parkettart.com). Lieferung solange erhältlich.

NO. 19 MARTIN KIPPENBERGER, JEFF KOONS, 1989

NO. 45 MATTHEW BARNEY, SARAH LUCAS, ROMAN SIGNER, 1995

OUT OF PRINT / VERGRIFFEN:

NO.

1 ENZO CUCCHI
2 SIGMAR POLKE
3 MARTIN DISLER
4 MERET OPPENHEIM
5 ERIC FISCHL
6 JANNIS KOUNELLIS
7 BRICE MARDEN
8 MARKUS RAETZ
9 FRANCESCO CLEMENTE
10 BRUCE NAUMAN
11 GEORG BASELITZ
12 ANDY WARHOL
13 REBECCA HORN
16 ROBERT WILSON
17 FISCHLI / WEISS
18 ED RUSCHA
19 JEFF KOONS, MARTIN KIPPENBERGER
20 TIM ROLLINS & K.O.S.
22 CHRISTIAN BOLTANSKI, JEFF WALL
23 RICHARD ARTSCHWAGER
24 ALIGHIERO BOETTI
25 KATHARINA FRITSCH, JAMES TURRELL
26 GÜNTHER FÖRG, PHILIP TAAFFE
27 LOUISE BOURGEOIS, ROBERT GOBER
29 CINDY SHERMAN, JOHN BALDESSARI
30 SIGMAR POLKE
31 DAVID HAMMONS, MIKE KELLEY
32 IMI KNOEBEL, SHERRIE LEVINE
33 ROSEMARIE TROCKEL, CHRISTOPHER WOOL
35 GERHARD RICHTER
36 STEFAN BALKENHOL, SOPHIE CALLE
38 ROSS BLECKNER, MARLENE DUMAS
39 FELIX GONZALEZ-TORRES, WOLFGANG LAIB
40/41 PETER FISCHLI / DAVID WEISS, GÜNTHER FÖRG, DAMIEN HIRST, JENNY HOLZER, REBECCA HORN, SIGMAR POLKE
45 MATTHEW BARNEY, SARAH LUCAS, ROMAN SIGNER

13

NO. 67 – COLLABORATIONS
JOHN BOCK
PETER DOIG
FRED TOMASELLI

205 p., ca. 150 illus.
ISBN 978-3-907582-17-6

NO. 66 – COLLABORATIONS
ANGELA BULLOCH
DANIEL BUREN
PIERRE HUYGHE

215 p., ca. 150 illus.
ISBN 978-3-907582-16-9

NO. 65 – COLLABORATIONS
JOHN CURRIN
LAURA OWENS
MICHAEL RAEDECKER

217 p., ca. 150 illus.
ISBN 978-3-907582-15-2

NO. 64 – COLLABORATIONS
OLAFUR ELIASSON
TOM FRIEDMAN
RODNEY GRAHAM

223 p., ca. 150 illus.
ISBN 978-3-907582-14-5

NO. 63 – COLLABORATIONS
TRACEY EMIN
WILLIAM KENTRIDGE
GREGOR SCHNEIDER

217 p., ca. 150 illus.
ISBN 978-3-907582-13-8

NO. 62 – COLLABORATIONS
JOHN WESLEY
TACITA DEAN
THOMAS DEMAND

213 p., ca. 150 illus.
ISBN 978-3-907582-12-1

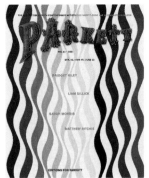

Cover: Bridget Riley

219 p., ca. 150 illus.
ISBN 978-3-907582-11-4

NO. 61 – COLLABORATIONS
BRIDGET RILEY
LIAM GILLICK
SARAH MORRIS
MATTHEW RITCHIE

Cover: Diana Thater

217 p., ca. 150 illus.
ISBN 978-3-907582-10-7

NO. 60 – COLLABORATIONS
CHUCK CLOSE
DIANA THATER
LUC TUYMANS

Cover: Kara Walker

219 p., ca. 150 illus.
ISBN 978-3-907582-09-1

NO. 59 – COLLABORATIONS
MAURIZIO CATTELAN
YAYOI KUSAMA
KARA WALKER

Cover: James Rosenquist

213 p., ca. 150 illus.
ISBN 978-3-907582-08-4

NO. 58 – COLLABORATIONS
JAMES ROSENQUIST
SYLVIE FLEURY
JASON RHOADES

Cover: Doug Aitken / Nan Goldin

215 p., ca. 150 illus.
ISBN 978-3-907582-07-7

NO. 57 – COLLABORATIONS
DOUG AITKEN
NAN GOLDIN
THOMAS HIRSCHHORN

Cover: Ellsworth Kelly

227 p., ca. 150 illus.
ISBN 978-3-907582-06-0

NO. 56 – COLLABORATIONS
ELLSWORTH KELLY
VANESSA BEECROFT
JORGE PARDO

Cover: Andreas Slominski

207 p. ca. 150 illus.
ISBN 978-3-907582-05-3

NO. 55 – COLLABORATIONS
**EDWARD RUSCHA
ANDREAS SLOMINSKI
SAM TAYLOR-WOOD**

Cover: Mariko Mori

207 p. ca. 150 illus.
ISBN 978-3-907582-04-6

NO. 54 – COLLABORATIONS
**RONI HORN
MARIKO MORI
BEAT STREULI**

Cover: Wolfgang Tillmans

207 p. ca. 150 illus.
ISBN 978-3-907582-03-9

NO. 53 – COLLABORATIONS
**TRACEY MOFFATT
ELIZABETH PEYTON
WOLFGANG TILLMANS**

Cover: Karen Kilimnik / Macolm Morley /
Ugo Rondinone

213 p. ca. 150 illus.
ISBN 978-3-907582-02-2

NO. 52 – COLLABORATIONS
**KAREN KILIMNIK
MALCOLM MORLEY
UGO RONDINONE**

303 p. ca. 200 illus.
ISBN 978-3-907582-00-8

NO. 50 / 51 – COLLABORATIONS
**JOHN M ARMLEDER, JEFF KOONS
JEAN-LUC MYLAYNE
THOMAS STRUTH, SUE WILLIAMS**

Cover: Douglas Gordon

225 p. ca. 150 illus.
ISBN 978-3-907509-99-9

NO. 49 – COLLABORATIONS
**LAURIE ANDERSON
DOUGLAS GORDON
JEFF WALL**

Cover: Gabriel Orozco

185 p., ca. 140 illus.
ISBN 978-3-907509-98-2

NO. 48 – COLLABORATIONS
GARY HUME
GABRIEL OROZCO
PIPILOTTI RIST

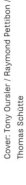

Cover: Tony Oursler / Raymond Pettibon /
Thomas Schütte

209 p., ca. 140 illus.
ISBN 978-3-907509-97-5

NO. 47 – COLLABORATIONS
TONY OURSLER
RAYMOND PETTIBON
THOMAS SCHÜTTE

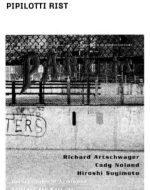

Cover: Richard Artschwager

219 p., ca. 150 illus.
ISBN 978-3-907509-96-8

NO. 46 – COLLABORATIONS
RICHARD ARTSCHWAGER
CADY NOLAND
HIROSHI SUGIMOTO

Cover: Andreas Gursky

225 p., ca. 150 illus.
ISBN 978-3-907509-94-4

NO. 44 – COLLABORATIONS
VIJA CELMINS
ANDREAS GURSKY
RIRKRIT TIRAVANIJA

Cover: Juan Muñoz / Susan Rothenberg

169 p., ca. 140 illus.
ISBN 978-3-907509-93-7

NO. 43 – COLLABORATIONS
JUAN MUÑOZ
SUSAN ROTHENBERG

Cover: Lawrence Weiner / Rachel Whiteread

179 p., ca. 140 illus.
ISBN 978-3-907509-92-0

NO. 42 – COLLABORATIONS
LAWRENCE WEINER
RACHEL WHITEREAD

Cover: Charles Ray

175 p. ca. 130 illus.
ISBN 978-3-907509-87-6

NO. 37 – COLLABORATIONS
**CHARLES RAY
FRANZ WEST**

Cover: Richard Prince / Ilya Kabakov

181 p. ca. 130 illus.
ISBN 978-3-907509-84-5

NO. 34 – COLLABORATIONS
**ILYA KABAKOV
RICHARD PRINCE**

Cover: Franz Gertsch / Thomas Ruff

183 p. ca. 130 illus.
ISBN 978-3-907509-78-4

NO. 28 – COLLABORATIONS
**FRANZ GERTSCH
THOMAS RUFF**

Cover: Alex Katz

161 p. ca. 120 illus.
ISBN 978-3-907509-71-5

NO. 21 – COLLABORATION
ALEX KATZ

Cover: Mario Merz

151 p. ca. 120 illus.
ISBN 978-3-907509-65-4

NO. 15 – COLLABORATION
MARIO MERZ

Cover: Gilbert & George

135 p. ca. 100 illus.
ISBN 978-3-907509-64-7

NO. 14 – COLLABORATION
GILBERT & GEORGE

OUT OF PRINT / VERGRIFFEN:

(See also p. 12f.)

NO.

NO.	
1	ENZO CUCCHI
2	SIGMAR POLKE
3	MARTIN DISLER
4	MERET OPPENHEIM
5	ERIC FISCHL
6	JANNIS KOUNELLIS
7	BRICE MARDEN
8	MARKUS RAETZ
9	FRANCESCO CLEMENTE
10	BRUCE NAUMAN
11	GEORG BASELITZ
12	ANDY WARHOL
13	REBECCA HORN
16	ROBERT WILSON
17	FISCHLI / WEISS
18	ED RUSCHA
19	JEFF KOONS, MARTIN KIPPENBERGER
20	TIM ROLLINS & K.O.S.
22	CHRISTIAN BOLTANSKI, JEFF WALL
23	RICHARD ARTSCHWAGER
24	ALIGHIERO BOETTI
25	KATHARINA FRITSCH, JAMES TURRELL
26	GÜNTHER FÖRG, PHILIP TAAFFE
27	LOUISE BOURGEOIS, ROBERT GOBER
29	CINDY SHERMAN, JOHN BALDESSARI
30	SIGMAR POLKE
31	DAVID HAMMONS, MIKE KELLEY
32	IMI KNOEBEL, SHERRIE LEVINE
33	ROSEMARIE TROCKEL, CHRISTOPHER WOOL
35	GERHARD RICHTER
36	STEFAN BALKENHOL, SOPHIE CALLE
38	ROSS BLECKNER, MARLENE DUMAS
39	FELIX GONZALEZ-TORRES, WOLFGANG LAIB
40/41	FRANCESCO CLEMENTE, GÜNTHER FÖRG, PETER FISCHLI / DAVID WEISS, DAMIEN HIRST, JENNY HOLZER, REBECCA HORN, SIGMAR POLKE
45	MATTHEW BARNEY, SARAH LUCAS, ROMAN SIGNER

Parkett Verlag, Quellenstrasse 27, CH-8031 Zürich,
phone +41-44-271 8140, fax +41-44-272 4301

Parkett Publishers, 145 Ave. of the Americas, New York, NY 10013,
phone (212) 673 2660, fax (212) 271 0704

info@parkettart.com, www.parkettart.com

A Large Lib

PARKETT

parkettart.com

BOOKS

LIBRARY
browse Parkett's over
90 volumes by spines

ALL BOOKS
explore 30 years and
1'400 texts by volume or
availability

SUBSCRIBE
or give a gift for 1, 2
or 3 years

SPECIAL TITLES
catalogue raisonné,
CD of all artists' Inserts,
set of 60 available
volumes et al.

OUT-OF-PRINT BOOKS
complete your library

AUTHORS' LIST
search texts by over
800 authors

EDITIONS

MUSEUM
tour the virtual
museum made by
artists for Parkett

ALL EDITIONS
explore over 220 edi-
tions by artist, volume,
media, or theme

OUT-OF-PRINT
rare edition offers

COMPLETE COLLECTION
the entire Set of all
works

ARTISTS

ARTISTS' LIST
search Parkett's
30 years

**ARTISTS'
DOCUMENTS &
ARCHIVE**
sketches and letters
on the making of
Parkett, short artists'
video statements and
more

wse the virtual libra

oks

rary

A Small Museum

EXPLORE MORE – ONLINE

NEWS & EXHIBITIONS

NEWS
on books, editions, exhibitions, artists talks, fairs and more

MUSEUM EXHIBITIONS
infos and pictures from Parkett exhibitions around the world

ZURICH EXHIBITION SPACE
upcomins and recent programs and events

JOIN MAILING LIST
stay tuned

ABOUT

INTRO

ABOUT

QUOTES
what others say

AD INFO
reach Parkett's readers worldwide – on- and offline

CONTACT
email or talk to us

> Find collabor artists & mor

> Enter the virtual rooms of all 220 works made by artists for Parkett

"... a catalyst for invigorating change whilst always producing the harvest of the quiet eye"

Hans Ulrich Obrist, Co-Director, Serpentine Gallery, London

of over

200 ARTWORKS – 25 YEARS
ARTISTS' EDITIONS FOR PARKETT

An authentic survey of today's art, this new catalogue raisonné features full page color illustrations of the 200 distinct and diverse artworks made by artists for Parkett since 1984 and further editorial core elements of Parkett's 25 years.

In her essay, Deborah Wye, Chief Curator, Department of Prints and Illustrated Books at the Museum of Modern Art, New York, looks at the different ways in which Parkett collaborates with artists, including the editions, inserts, spines, covers, texts and the design of the publication. The text by Susan Tallman explores the diversity and richness of the artists' editions, which represent a unique "Musée en Appartement" with distinct responses from many of the most inspiring and influential contemporary artists worldwide. Texts in English and Japanese, Published on the occasion of Parkett's 25 year retrospective at the 21st Century Museum of Contemporary Art, Kanazawa, Japan.

200 full-page color reproductions of all editions, artists' sketches and letters, color reproductions of 85 Parkett Covers, index of all 800 authors and 1400 texts.

520 pages, 19,4 x 16 cm / 7 $^1/_2$ x 6 $^3/_8$".
€ 38.– / $ 48.00 / CHF 49.– (excl. postage).

ISBN 978-3-907582-25-1

POSTCARD SET
OF PARKETT'S ARTISTS' EDITIONS
+ TEXT BOOKLET FROM MOMA SHOW

This box with 170 color postcards of Parkett's ingenious and fascinating editions, objects, prints and other works provides a summation of some of the most vital and exciting aspects of contemporary art.

The box also contains a 64 page booklet with texts from Parkett's MoMA show by Deborah Wye, Chief Curator, Prints and Illustrated Books, Museum of Modern Art, New York, and Susan Tallman, art historian and book author. The booklet also includes color reproductions of some 60 Parkett covers.

Box with 170 color Postcards and 64 page Booklet, 16 x 12 x 6 cm / 6 $^1/_4$ x 4 $^3/_4$ x 2 $^3/_8$".
€ 32.– / $ 39.00 / CHF 45.– (excl. postage).

ISBN 3-907582-23-3

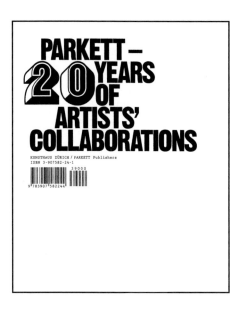

PARKETT – 20 YEARS OF ARTISTS' COLLABORATIONS

"A rare behind-the-scenes look at one of the art world's most respected magazines" D.A.P., New York

"Parkett – 20 Years of Artists' Collaborations" portrays and explores the 20 years of Parkett since 1984. It focuses particularly on the making of the publication's signature artist' collaborations and editions, which are featured with artists' documents, interviews, statements and other background information. The catalogue also includes artists' documents on the making of Parkett's editions and issues with some 30 full-page drawings and comments by various artists.

Edited in English and German by Mirjam Varadinis, Curator Kunsthaus Zurich. Foreword by Christoph Becker, Director, Kunsthaus Zurich. Published on the occasion of the Parkett Exhibition "20 Years of Artists' Collaborations" at Kunsthaus Zurich (2005).
248 pages, 9 x 7.4" / 23 x 19 cm, paperback with dust jacket, 120 reproductions, 30 in color, designed by Elektrosmog, published by Parkett, € 36.– / $ 48.00 / CHF 45.– excl. postage.

ISBN: 3-907582-24-1

Parkett – 20 Years of Artists' Collaborations dokumentiert und erzählt die 20-jährige Geschichte der Zeitschrift seit ihrer Gründung im Jahr 1984. Anhand von Dokumenten, Interviews und Hintergrundinformationen wird besonders die Entstehung der von den Künstlern begleiteten Layouts – und der Künstlereditionen hervorgehoben. Der Katalog enthält über 30 Seiten mit Künstlerdokumenten, die zeigen, wie unmittelbar die Künstler bei der Entstehung der Zeitschrift und der Editionen beteiligt sind.

Herausgegeben von Mirjam Varadinis, Kuratorin Kunsthaus Zürich, Vorwort von Christoph Becker, Direktor Kunsthaus Zürich, herausgegeben anlässlich der Ausstellung "20 Years of Artists' Collaborations" im Kunsthaus Zürich (2005). 248 Seiten, Softcover mit Schutzumschlag, Design: Elektrosmog.
€ 36.– / $ 48.00 / CHF 45.– exkl. Versandkosten.

ISBN: 3-907582-24-1

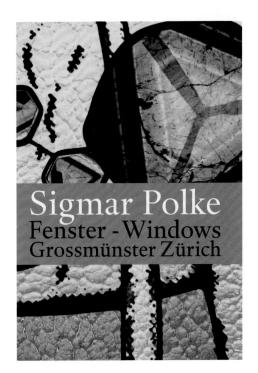

SIGMAR POLKE'S WINDOWS FOR THE ZÜRICH GROSSMÜNSTER

SIGMAR POLKE DIE FENSTER FÜR DAS GROSSMÜNSTER ZÜRICH

Texts by / Texte von:
Marina Warner, Gottfried Boehm,
Katharina Schmidt,
Jacqueline Burckhardt / Bice Curiger,
Ulrich Gerster / Regine Helbling,
Käthi La Roche, Urs Rickenbach,
Claude Lambert.

«This high-quality book crowns an outstanding project – diverse, in-depth, poetic – as this artist's work deserves.»

«Die hochkarätige Buchpublikation ... setzt dem ohnehin herausragenden Projekt die Krone auf ... vielseitig, tief lotend, poetisch ... wie es der Arbeit dieses Künstlers gebührt.»

NZZ, Zurich

Sigmar Polke recently completed a series of twelve windows for the Grossmunster cathedral in Zurich, setting new standards for the mutual relationship between art and church. One group of seven Romanesque windows shows luminous 'mosaics' of thinly sliced agate, some of it artificially colored, to produce pulsating blocks of back-lit color. Says Marina Warner, "The interior of rocks opens not only on unexpected colors... on once imprisoned now scintillating rays and gleams, but it also tunnels into the past, into the distant past of geological and cosmological millennia." For the remaining five windows, Polke designed images of figures from the Old Testament, based on medieval illuminations, which have themselves undergone transformation in the course of their long journey through time. Polke's figures now appear as radiantly contemporary icons created in colored glass, using a variety of traditional and customized techniques devised especially for this project.

Vor kurzem vollendete Sigmar Polke den Zyklus von zwölf Fenstern im Grossmünster Zürich und setzte dabei neue Massstäbe im Verhältnis Kunst und Kirche. Eine Gruppe der Fenster besteht aus geschnittenen, teilweise künstlich gefärbten Achatscheiben, die im romanischen Bau wie «leuchtende Mosaike», aufscheinen. Marina Warner schreibt: «Das Innere von Gesteinsbrocken kann nicht nur unerwartete Farben, vor Zeiten Eingesperrtes, heute funkelndes Strahlen und Schimmern enthüllen, es öffnet auch einen Blick zurück in die unendlich ferne Vergangenheit geologischer und kosmologischer Jahrtausende.» Die weiteren Fenster aus Buntglas gestaltete Polke nach Motiven des Alten Testaments. Sie basieren auf mittelalterlichen Illustrationen, die ihrerseits in einer langen Zeitreise ihre Transformation erlebt haben und jetzt als höchst zeitgenössische Ikonen erstrahlen. Die Bilder wurden in einer Vielfalt von traditionellen und neu dafür entwickelten Techniken im Glas selber zur Entstehung gebracht und nicht wie üblich auf das Glas aufgetragen.

Hardcover, 28 x 20 cm / 11 x 8", 272 pages, approx. 70 color images
English – German Edition, Parkett Publishers in Collaboration with Grossmünster Zürich
€ 45.– / $ 65.00 / CHF 68.–

ISBN 978-3-907582-27-5

Parkett Verlag
Quellenstrasse 27
CH-8031 Zürich
phone +41-44-271 8140
fax +41-44-272 4301

Parkett Publishers
145 Ave. of the Americas
New York, NY 10013
phone (212) 673 2660
fax (212) 271 0704

info@parkettart.com
www.parkettart.com

If you have any questions or wish to place an order, please contact your book shop or book distributor nearest you or Parkett in Zurich or New York.

Ihre Fragen oder Bestellungen können Sie gerne direkt an Ihre Buchhandlung oder Ihren Buchvertrieb oder an Parkett in Zürich oder New York richten.

Distributors

North America, Asia, and Australia

D.A.P. / Distributed Art Publishers, Inc.
155 Sixth Avenue, 2nd floor
New York, NY 10013 - USA
Email orders@dapinc.com
Tel. (212) 627 1999
Fax. (212) 627 9484
www.artbook.com

Great Britan and other territories

Central Books Ltd
99 Wallis Road
London E9 5LN
Email magazines@centralbooks.com
Tel. 44 (0) 845 458 99 11
Fax. 44 (0) 845 458 99 12
www.centralbooks.com

Germany and other territories / Deutschland und andere Länder

GVA Gemeinsame Verlagsauslieferung
Anna-Vandenhoeck-Ring 36
D-37010 Göttingen
Email info@gva-verlage.de
Tel. 49 (0) 551 384 2000
Fax. 49 (0) 551 384 20010
www.gva-verlage.de

Holland, Belgium, and Luxemburg

Ideabooks
Nieuwe Herengracht 11
NL-1011 RK Amsterdam
Email idea@ideabooks.nl
Tel. 0031 20 622 61 54
Tex. 0031 20 620 92 99
www.ideabooks.nl

Switzerland / Schweiz

AVA Verlagsauslieferung AG
Centralweg 16
CH-8910 Affoltern a. A.
Email buchundinfo@ava.ch
Tel. 044 762 42 70
Fax. 044 762 42 10
www.ava.ch

ARTISTS' MONOGRAPHS & EDITIONS / KÜNSTLERMONOGRAPHIEN & EDITIONEN

● = available monograph / erhältliche Monographie ● = available edition / erhältliche Edition
Delivery subject to availability at time of order / Lieferung solange Vorrat

Column 1

- 99 Lynette Yiadom-Boakye
- Omer Fast
- Cao Fei
- Adrian Ghenie
- 98 Ed Atkins
- Theaster Gates
- Lee Kit
- Mika Rottenberg
- 97 Andrea Büttner
- Abraham Cruzvillegas
- Camille Henrot
- Hito Steyerl
- 96 Marc Camille Chaimowicz
- Pamela Rosenkranz
- John Waters
- Xu Zhen
- 95 Jeremy Deller
- Wael Shawky
- Dayanita Singh
- Rosemarie Trockel
- 94 Tauba Auerbach
- Cyprien Gaillard
- Ragnar Kjartansson
- Shirana Shahbazi
- 93 Valentin Carron
- Frances Stark
- Adrian Villar Rojas
- Danh Vo
- 92 Jimmie Durham
- Helen Marten
- Paulina Olowska
- Damián Ortega
- 91 Yto Barrada
- Nicole Eisenmann
- Liu Xiaodong
- Monika Sosnowska
- 90 El Anatsui
- Nathalie Djurberg
- Rashid Johnson
- R.H. Quaytman
- 89 Mark Bradford
- Charline von Heyl
- Oscar Tuazon
- Haegue Yang
- 88 Kerstin Brätsch
- Paul Chan
- Sturtevant
- Andro Wekua
- 87 Katharina Fritsch
- Annette Kelm
- Kelley Walker
- Cerith Wyn Evans
- 86 John Baldessari
- Carol Bove
- Josiah McElheny
- Philippe Parreno
- 85 Maria Lassnig
- Beatriz Milhazes
- Jean-Luc Mylayne
- Josh Smith
- 84 Tomma Abts
- Zoe Leonard
- Mai-Thu Perret
- 83 Robert Frank
- Wade Guyton
- Christopher Wool
- 82 Pawel Althamer
- Louise Bourgeois
- Rachel Harrison
- 81 Ai Weiwei
- Cosima von Bonin
- Christian Jankowski
- 80 Allora & Calzadilla
- D. Gonzalez-Foerster
- Mark Grotjahn
- 79 Albert Oehlen
- Jon Kessler
- Marilyn Minter
- 78 Ernesto Neto
- Olaf Nicolai
- Rebecca Warren
- 77 Trisha Donnelly
- Carsten Höller

Column 2

- Rudolf Stingel
- 76 Lucy McKenzie
- Julie Mehretu
- Yang Fudong
- 75 Kai Althoff
- Glenn Brown
- Dana Schutz
- 74 Bernard Frize
- Katharina Grosse
- Richard Serra
- 73 Ellen Gallagher
- Paul McCarthy
- Anri Sala
- 72 Monica Bonvicini
- Urs Fischer
- Richard Prince
- 71 Olaf Breuning
- Richard Phillips
- Keith Tyson
- 70 Christian Marclay
- Wilhelm Sasnal
- Gillian Wearing
- 69 Francis Alÿs
- Isa Genzken
- Anish Kapoor
- 68 Franz Ackermann
- Eija-Liisa Ahtila
- Dan Graham
- 67 John Bock
- Peter Doig
- Fred Tomaselli
- 66 Angela Bulloch
- Daniel Buren
- Pierre Huyghe
- 65 John Currin
- Laura Owens
- Michael Raedecker
- 64 Olafur Eliasson
- Tom Friedman
- Rodney Graham
- 63 Tracey Emin
- William Kentridge
- Gregor Schneider
- 62 Tacita Dean
- Thomas Demand
- John Wesley
- 61 Liam Gillick
- Sarah Morris
- Bridget Riley
- Matthew Ritchie
- 60 Chuck Close
- Diana Thater
- Luc Tuymans
- 59 Maurizio Cattelan
- Yayoi Kusama
- Kara Walker
- 58 Sylvie Fleury
- Jason Rhoades
- James Rosenquist
- 57 Doug Aitken
- Nan Goldin
- Thomas Hirschhorn
- 56 Vanessa Beecroft
- Ellsworth Kelly
- Jorge Pardo
- 55 Edward Ruscha
- Andreas Slominski
- Sam Taylor-Wood
- 54 Roni Horn
- Mariko Mori
- Beat Streuli
- 53 Tracey Moffatt
- Elizabeth Peyton
- Wolfgang Tillmans
- 52 Karen Kilimnik
- Malcolm Morley
- Ugo Rondinone
- 50/51 John Armleder
- Jeff Koons
- Jean-Luc Mylayne
- Thomas Struth
- Sue Williams
- 49 Laurie Anderson

Column 3

- Douglas Gordon
- Jeff Wall
- 48 Gary Hume
- Gabriel Orozco
- Pipilotti Rist
- 47 Tony Oursler
- Raymond Pettibon
- Thomas Schütte
- 46 Richard Artschwager
- Cady Noland
- Hiroshi Sugimoto
- 45 Matthew Barney
- Sarah Lucas
- Roman Signer
- 44 Vija Celmins
- Andreas Gursky
- Rirkrit Tiravanija
- 43 Juan Muñoz
- Susan Rothenberg
- 42 Lawrence Weiner
- Rachel Whiteread
- 40/41 Francesco Clemente
- Fischli/Weiss
- Günther Förg
- Damien Hirst
- Jenny Holzer
- Rebecca Horn
- Sigmar Polke
- 39 Felix Gonzalez-Torres
- Wolfgang Laib
- 38 Ross Bleckner
- Marlene Dumas
- 37 Charles Ray
- Franz West
- 36 Stephan Balkenhol
- Sophie Calle
- 35 Gerhard Richter
- 34 Ilya Kabakov
- Richard Prince
- 33 Rosemarie Trockel
- Christopher Wool
- 32 Imi Knoebel
- Sherrie Levine
- 31 David Hammons
- Mike Kelley
- 30 Sigmar Polke
- 29 John Baldessari
- Cindy Sherman
- 28 Franz Gertsch
- Thomas Ruff
- 27 Louise Bourgeois
- Robert Gober
- 26 Günther Förg
- Philip Taaffe
- 25 Katharina Fritsch
- James Turrell
- 24 Alighiero e Boetti
- 23 Richard Artschwager
- 22 Christian Boltanski
- Jeff Wall
- 21 Alex Katz
- 20 Tim Rollins + K.O.S.
- 19 Martin Kippenberger
- Jeff Koons
- 18 Ed Ruscha
- 17 Fischli/Weiss
- 16 Robert Wilson
- 15 Mario Merz
- 14 Gilbert & George
- 13 Rebecca Horn
- Andy Warhol
- 11 Georg Baselitz
- 10 Bruce Nauman
- 9 Francesco Clemente
- 8 Markus Raetz
- 7 Brice Marden
- 6 Jannis Kounellis
- 5 Eric Fischl
- 4 Meret Oppenheim
- 3 Martin Disler
- 2 Sigmar Polke
- 1 Enzo Cucchi

SUBSCRIBE, COMPLETE OR SEND A GIFT SUBSCRIPTION FOR THE BEST BOOK SERIES ON CONTEMPORARY ARTISTS www.parkettart.com

☐ I wish to subscribe (or give a gift subscription) starting with vol. no. _____ for (Postage incl., prices subject to change):

 ☐ 1 year (2 vol.) at € 72.– (Europe) / US $ 78 (USA/CAN), € 82.– (Rest of world)

 ☐ 2 years (4 vol.) at € 128.– (Europe) / US $ 148 (USA/CAN), € 164.– (Rest of world)

 ☐ 3 years (6 vol.) at € 185.– (Europe) / US $ 205 (USA/CAN), € 238.– (Rest of world)

☐ I wish to complete my PARKETT library and order the following **volumes**:

No. _____

at € 30.– (Europe, rest of world), US $ 32 (USA/Canada) each, plus postage. Sold out: No. 1–13, 16–20, 22–27, 29–33, 35, 36, 38–41, 45. As of vol. 88: € 39.– / US $ 45.

☐ I wish to order the **Set of all 60 available Parkett volumes** at € 990 (Europe, rest of world), US $ 1,250 (USA/Canada), plus postage (see p. 10).

☐ I wish to order _____ copies of **"200 Artworks – 25 Years"**, catalogue raisonné of Parketts' editions (see p. 22). 520 p., with two essays, 200 color repr., € 38.– (Europe, rest of world), US $ 48 (USA/Canada), plus postage.

☐ I wish to order _____ copies of "PARKETT–20 Years of Artists' Collaborations", € 38.– / US $ 48.00 (see p. 23)

☐ I wish to order _____ copies of the Postcard Set of Parkett's Artists' Editions, € 32.–/US $ 39 (see p. 22)

☐ I wish to order _____ copies of **"Sigmar Polke – Windows for the Zurich Grossmünster,** € 45.– / $ 65, (plus postage)

Prices subject to change. For further information please go to www.parkettart.com or contact us at info@parkettart.com.

NAME: _____

SURNAME: _____

ADDRESS: _____

CITY: _____

STATE/ZIP/COUNTRY: _____

TEL.: _____ FAX: _____

E-MAIL: _____

GIFT RECIPIENT: _____

SURNAME: _____

ADDRESS: _____

STATE/ZIP/COUNTRY: _____

Charge my
☐ Visa ☐ Eurocard/Mastercard ☐ Amex

Card No. |__|__|__|__|__|__|__|__|__|__|__|

Expiration date

☐ Bill me

Date

Signature

ABONNIEREN, VERVOLLSTÄNDIGEN ODER SCHENKEN SIE DIE UMFASSENDSTE BUCHREIHE ÜBER GEGENWARTSKÜNSTLER www.parkettart.com

☐ Ich abonniere (verschenke) Parkett ab Band Nr. _____ für (Preise inkl. Versandkosten. Preisänderungen vorbehalten):

 ☐ 1 Jahr (2 Bände) zu € 72.– (Europa), CHF 95.– (Schweiz)

 ☐ 2 Jahre (4 Bände) zu € 128.– (Europa), CHF 168.– (Schweiz)

 ☐ 3 Jahre (6 Bände) zu € 185.– (Europa), CHF 248.– (Schweiz)

☐ Ich möchte meine PARKETT-Bibliothek vervollständigen und bestelle die folgenden noch erhältliche(n) **Bände**:

Nr. _____

zu je € 30 / CHF 45.–, zzgl. Versandkosten, (vergriffen: Nr. 1–13, 16–20, 22–27, 29–33, 35, 36, 38–41, 45). Ab Nr. 88: € 39.–, CHF 55.–.

☐ Ich bestelle den **Set aller 60 erhältlichen Parkett-Bände** (S. 11) zu € 990 (Europa), CHF 1400.– (Schweiz), zzgl. Versandkosten.

☐ Ich bestelle _____ Ex. **«200 Artworks – 25 Years»**, Werkkatalog aller Parkett Künstler-Editionen (siehe S. 22). 516 S., mit Texten, 200 Farbabb., € 35.– / CHF 49.–, zzgl. Versandkosten.

☐ Ich bestelle ___ Ex. **«Parkett – 20 Years of Artists' Collaborations»** (siehe S. 23), € 32.– / CHF 45.–, zzgl. Versandkosten.

☐ Ich bestelle ___ Ex. **«Sigmar Polke's Fenster für das Zürcher Grossmünster»** (siehe S. 24), € 45.– / CHF 68.–, zzgl. Versandkosten.

Preisänderungen vorbehalten.

NAME: _____

STRASSE: _____

PLZ/STADT: _____

LAND: _____

TEL.: _____ FAX: _____

E-MAIL: _____

BESCHENKTE(R): _____

STRASSE: _____

PLZ/STADT: _____

LAND: _____

Ich zahle mit ☐ Visa ☐ Eurocard/Mastercard ☐ Amex

Karten Nr. |__|__|__|__|__|__|__|__|__|__|__|

Gültig bis

☐ Bitte senden Sie mir eine Rechnung.

Datum

Unterschrift

Send this form to the PARKETT office nearest you: / Senden Sie die Bestellkarte an das Parkett-Büro in Ihrer Nähe:
Parkett Publishers 145 Av. of the Americas New York, NY 10013 Phone (212) 673-2660 Fax (212) 271-0704
Parkett Verlag Quellenstrasse 27 CH-8031 Zürich Phone +41-44-271 81 40 Fax +41-44-272 43 01
Or order online at: www.parkettart.com / Oder bestellen Sie online: www.parkettart.com

COLLABORATIONS & EDITIONS NO. 1–99

Tomma Abts, vol. 84
Franz Ackermann, vol. 68
Eija-Liisa Ahtila, vol. 68
Ai Weiwei, vol. 81
Doug Aitken, vol. 57
Jennifer Allora /
Guillermo Calzadilla, vol. 80
Pavel Althamer, vol. 82
Kai Althoff, vol. 75
Francis Alÿs, vol. 69
El Anatsui, vol. 90
Laurie Anderson, vol. 49
John Armleder, vol. 50/51
Richard Artschwager, vol. 23, vol. 46
Ed Atkins, vol. 98
Tauba Auerbach, vol. 94
John Baldessari, vol. 29, 86
Stephan Balkenhol, vol. 36
Matthew Barney, vol. 45
Yto Barrada, vol. 91
Georg Baselitz, vol. 11
Vanessa Beecroft, vol. 56
Ross Bleckner, vol. 38
John Bock, vol. 67
Alighiero e Boetti, vol. 24
Christian Boltanski, vol. 22
Monica Bonvicini, vol. 72
Louise Bourgeois, vol. 27, 82
Carol Bove, vol. 86
Mark Bradford, vol. 89
Kerstin Brätsch, vol. 88
Olaf Breuning, vol. 71
Glenn Brown, vol. 75
Angela Bulloch, vol. 66
Daniel Buren, vol. 66
Andrea Büttner, vol. 97
Sophie Calle, vol. 36
Valentin Carron, vol. 93
Maurizio Cattelan, vol. 59
Vija Celmins, vol. 44
Marc Camille Chaimowicz, vol. 96
Paul Chan, vol. 88
Francesco Clemente, vol. 9 & 40/41
Chuck Close, vol. 60
Abraham Cruzvillegas, vol. 97
Enzo Cucchi, vol. 1
John Currin, vol. 65
Tacita Dean, vol. 62
Jeremy Deller, vol. 95
Thomas Demand, vol. 62
Martin Disler, vol. 3
Nathalie Djurberg vol. 90
Peter Doig, vol. 67
Trisha Donnelly, vol. 77
Marlene Dumas, vol. 38
Jimmie Durham, vol. 92
Nicole Eisenman, vol. 91
Olafur Eliasson, vol. 64

Tracey Emin, vol. 63
Omer Fast, vol. 99
Cao Fei, vol. 99
Urs Fischer, vol. 72, 94
Eric Fischl, vol. 5
Peter Fischli / David Weiss, vol. 17, 40/41
Sylvie Fleury, vol. 58
Günther Förg, vol. 26 & 40/41
Robert Frank, vol. 83
Tom Friedman, vol. 64
Katharina Fritsch, vol. 25, 87
Bernard Frize, vol. 74
Cyprien Gaillard, vol. 94
Ellen Gallagher, vol. 73
Theaster Gates, vol. 98
Isa Genzken, vol. 69
Franz Gertsch, vol. 28
Adrian Ghenie, vol. 99
Gilbert & George, vol. 14
Liam Gillick, vol. 61
Robert Gober, vol. 27
Nan Goldin, vol. 57
Dominique Gonzalez-Foerster, vol. 80
Felix Gonzalez-Torres, vol. 39
Douglas Gordon, vol. 49
Dan Graham, vol. 68
Rodney Graham, vol. 64
Katharina Grosse, vol. 74
Mark Grotjahn, vol. 80
Andreas Gursky, vol. 44
Wade Guyton, vol. 83
David Hammons, vol. 31
Rachel Harrison, vol. 82
Camille Henrot, vol. 97
Charline von Heyl, vol. 89
Thomas Hirschhorn, vol. 57
Damien Hirst, vol. 40/41
Carsten Höller, vol. 77
Jenny Holzer, vol. 40/41
Rebecca Horn, vol. 13 & 40/41
Roni Horn, vol. 54
Gary Hume, vol. 48
Pierre Huyghe, vol. 66
Christian Jankowski, vol. 81
Rashid Johnson vol. 90
Ilya Kabakov, vol. 34
Anish Kapoor, vol. 69
Alex Katz, vol. 21, 72
Mike Kelley, vol. 31
Ellsworth Kelly, vol. 56
Annette Kelm, vol. 87
William Kentridge, vol. 63
Jon Kessler, vol. 79
Karen Kilimnik, vol. 52
Martin Kippenberger, vol. 19
Lee Kit, vol. 98
Ragnar Kjartansson, vol. 94
Imi Knoebel, vol. 32

Jeff Koons, vol. 19, 50/51
Jannis Kounellis, vol. 6
Yayoi Kusama, vol. 59
Wolfgang Laib, vol. 39
Maria Lassnig, vol. 85
Zoe Leonard, vol. 84
Sherrie Levine, vol. 32
Liu Xiaodong. vol. 91
Sarah Lucas, vol. 45
Christian Marclay, vol. 70
Brice Marden, vol. 7
Helen Marten, vol. 92
Paul McCarthy, vol. 73
Josiah McElheny, vol. 86
Lucy McKenzie, vol. 76
Julie Mehretu, vol. 76
Mario Merz, vol. 15
Beatriz Milhazes, vol. 85
Marilyn Minter, vol. 79
Tracey Moffatt, vol. 53
Mariko Mori, vol. 54
Malcolm Morley, vol. 52
Sarah Morris, vol. 61
Juan Muñoz, vol. 43
Jean-Luc Mylayne, vol. 50/51, 85
Bruce Nauman, vol. 10
Ernesto Neto, vol. 78
Olaf Nicolai, vol. 78
Cady Noland, vol. 46
Albert Oehlen, vol. 79
Paulina Olowska, vol. 92
Meret Oppenheim, vol. 4
Gabriel Orozco, vol. 48
Damián Ortega, vol. 92
Tony Oursler, vol. 47
Laura Owens, vol. 65
Jorge Pardo, vol. 56
Philippe Parreno, vol 86
Mai-Thu Perret, vol. 84
Raymond Pettibon, vol. 47
Elizabeth Peyton, vol. 53
Richard Phillips, vol. 71
Sigmar Polke, vol. 2, 30 & 40/41
Richard Prince, vol. 34, 72
R.H. Quaytman, vol. 90
Michael Raedecker, vol. 65
Markus Raetz, vol. 8
Charles Ray, vol. 37
Jason Rhoades, vol. 58
Gerhard Richter, vol. 35
Bridget Riley, vol. 61
Pipilotti Rist, vol. 48, 71
Matthew Ritchie, vol. 61
Tim Rollins & K.O.S., vol. 20
Ugo Rondinone, vol. 52
Pamela Rosenkranz, vol. 96
James Rosenquist, vol. 58
Mika Rottenberg, vol. 98

Susan Rothenberg, vol. 43
Thomas Ruff, vol. 28
Edward Ruscha, vol. 18 & 55
Anri Sala, vol. 73
Wilhelm Sasnal, vol. 70
Gregor Schneider, vol. 63
Thomas Schütte, vol. 47
Dana Schutz, vol. 75
Richard Serra, vol. 74
Shirana Shahbazi, vol. 94
Wael Shawky, vol. 95
Cindy Sherman, vol. 29
Roman Signer, vol. 45
Andreas Slominski, vol. 55
Josh Smith, vol. 85
Dayanita Singh, vol. 95
Monika Sosnowska, vol. 91
Frances Stark, vol. 93
Hito Steyerl, vol 97
Rudolf Stingel, vol. 77
Beat Streuli, vol. 54
Thomas Struth, vol. 50/51
Sturtevant, vol. 88
Hiroshi Sugimoto, vol. 46
Philip Taaffe, vol. 26
Sam Taylor-Wood, vol. 55
Diana Thater, vol. 60
Wolfgang Tillmans, vol. 53
Rirkrit Tiravanija, vol. 44
Fred Tomaselli, vol. 67
Rosemarie Trockel, vol. 33, 95
Oscar Tuazon, vol. 89
James Turrell, vol. 25
Luc Tuymans, vol. 60
Keith Tyson, vol. 71
Adrián Vilar Rojas, vol 93
Danh Vo, vol. 93
Cosima von Bonin, vol. 81
Kara Walker, vol. 59
Kelley Walker, vol. 87
Jeff Wall, vol. 22 & 49
Andy Warhol, vol. 12
Rebecca Warren, vol. 78
John Waters, vol. 96
Gillian Wearing, vol. 70
Lawrence Weiner, vol. 42
Andro Wekua, vol. 88
John Wesley, vol. 62
Franz West, vol. 37, 70
Rachel Whiteread, vol. 42
Sue Williams, vol. 50/51
Robert Wilson, vol. 16
Christopher Wool, vol. 33, 83
Cerith Wyn Evans, vol. 87
Xu Zhen, vol 96
Yang Fudong, vol. 76
Haegue Yang, vol. 89
Lynette Yiadom-Boakye, vol. 99

 ARTISTS' EDITIONS FOR PARKETT SUBSCRIBERS www.parkettart.com

The Parkett Series is created in collaboration with artists, who contribute an original work available exclusively to the subscribers in the form of a signed limited Special Edition. The available works are also reproduced in each Parkett issue.

Each Special Edition can be ordered online or from any one of our offices in New York or Zurich. Just fill in the details below and send this card to the office nearest you. Once your order has been processed, you will be issued with an invoice and your personal edition number. Upon receipt of payment, you will receive the Special Edition. (Please note that supply is subject to availability. Parkett does not assume responsibility for any delays in production of Special Editions. Postage and VAT not included.)

☐ As a subscriber to Parkett, I would like to order the following Special Edition(s), signed and numbered by the artist.

PARKETT No.	Artist	NAME:
PARKETT No.	Artist	ADDRESS:
PARKETT No.	Artist	CITY:
PARKETT No.	Artist	STATE / ZIP:
PARKETT No.	Artist	COUNTRY:
PARKETT No.	Artist	PHONE:

☐ I have indicated my way of payment at the back on p. 27.

Send this form to the PARKETT office nearest you:
Parkett Publishers 145 Av. of the Americas New York, NY 10013 Phone (212) 673-2660 Fax (212) 271-0704
Parkett Verlag Quellenstrasse 27 CH-8031 Zürich Phone +41-44-271 81 40 Fax +41-44-272 43 01
Visit our website: www.parkettart.com

PARKETT **KÜNSTLEREDITIONEN FÜR PARKETT-ABONNENTEN** www.parkettart.com

Die Parkett-Buchreihe entsteht in Zusammenarbeit mit Künstlern, die eigens für die Abonnenten einen Original-beitrag in Form einer limitierten und signierten Edition gestalten. Diese Editionen sind auch in der Zeitschrift abgebildet und können online oder mit dieser Bestellkarte in jedem unserer Büros in Zürich oder New York be-stellt werden. Sie erhalten dann Ihre persönliche Editionsnummer und eine Rechnung. Sobald wir Ihre Zahlung erhalten haben, schicken wir Ihnen Ihre Edition(en). Lieferung solange Vorrat. Parkett übernimmt keine Verant-wortung für allfällige Verzögerungen bei der Herstellung der Vorzugsausgaben. Versandkosten und MwSt nicht inbegriffen.

☐ Ich bin Parkett-Abonnent(in) und bestelle folgende Edition(en), nummeriert und vom Künstler signiert:

PARKETT Nr.	Künstler/in	NAME:
PARKETT Nr.	Künstler/in	STRASSE:
PARKETT Nr.	Künstler/in	PLZ/ORT:
PARKETT Nr.	Künstler/in	LAND:
PARKETT Nr.	Künstler/in	TEL:

☐ Die Zahlungsweise habe ich hinten auf Seite 27 angegeben.

Senden Sie die Bestellkarte an das Parkett-Büro in Ihrer Nähe:
Parkett Verlag Quellenstrasse 27 CH-8031 Zürich Phone +41-44-271 81 40 Fax +41-44-272 43 01
Parkett Publishers 145 Av. of the Americas New York, NY 10013 Phone (212) 673-2660 Fax (212) 271-0704
Oder bestellen Sie online: www.parkettart.com

"The collections of The Museum of Modern Art contain numerous examples of editions by the most significant artists of the modern period ... The editions commissioned by Parkett carry on this rich tradition ... All the works are on view together in one large gallery, creating a concise survey of cwontemporary art ..."

Deborah Wye, Chief Curator of Prints and Illustrated Books,
The Museum of Modern Art, New York

Parkett ExhibItion at the Museum of Modern Art, New York, 2001

MUSEUM EXHIBITIONS
(Selection)

Taipei Fine Arts Museum, Taiwan
(May – Aug, 2013) "Parkett – 220 Artists Collaborations & Editions."
The most complete exhibition to date presents all 220 works made by artists for Parkett, with catalog in Chinese and English, 512 p.

Ullens Center for Contemporary Art, Beijing
(February – April, 2012) "Inside a Book a House of Gold – Artists' Editions for Parkett"

Seoul Arts Center-Hangaram Museum, Korea
(Dec 2010 – Feb 2011) "200 Artworks – 25 Years" catalog in Korean.

Singapore Tyler Print Institute STPI
(May – July 2010) "200 Artworks – 25 Years"

Kanazawa, 21st Century Museum of Contemporary Art (September 2009)
"25 Years Parkett editions",
with catalog in English and Japanese.

Zurich, Kunsthaus
(November, 2004 – February, 2005)
"Parkett – 20 Years of Artists' Collaborations"
Curated by Miriam Varadinis, with catalog.

Venice, Palazzo Remer (June – October, 2003)
At the occasion of the Biennale this exhibition presented all Parkett editions in Venice.

Dublin, Irish Museum of Modern Art
(June – October, 2002) "Beautiful Productions"

London, Whitechapel Art Gallery
(July – August, 2001)
"Beautiful Productions: Art to Play, Art to Wear, Art to Own", curated by Iwona Blazwick.

New York, Museum of Modern Art
(April – June, 2001)
"Collaborations with Parkett: 1984 to Now", curated by Deborah Wye, with catalog.

Geneva, Centre d'Art Contemporain
(November, 1999)

Siena, Palazzo delle Papesse
(June – October, 1999)

Cologne, Ludwig Museum
(November 1998 – January, 1999
Curated by Reinhold Misselbeck, with catalog.

Humlebaek, Denmark, Louisiana Museum
(September – October, 1996)
Curated by Lars Grambye

Los Angeles, MAK-Center at the Schindler House
(March – June, 1995)
Catalog "Silent & Violent" edited by Peter Noever.

Geneva, Centre de Gravure Contemporaîne
(April – May, 1992)

Marseille, Centre de la vielle Chariteé, Museés de Marseille (February – March, 1991)

Zurich, Helmhaus (January – February, 1989)

Frankfurt, Portikus (September – October, 1988)

Paris, Centre Georges Pompidou
(April – June, 1987)

1 A

2 A

3 A

DANIEL BUREN

UNIQUE TABLECLOTH WITH LASER-CUT LACE (OBJECT TO BE SITUATED ON TABLE), **2002** (Parkett 66)

Two-layered tablecloth: off-white laser-cut design on monochrome underlayer.
Each tablecloth has a unique combination of design and color. Top layer 70 $^7/_8$ x 70 $^7/_8$";
bottom layer 67 x 67"; design 30 $^{11}/_{16}$ x 30 $^{11}/_{16}$"; width of stripes 8.7 cm.
Washable polyester, laser-cut and produced by Jakob Schläpfer AG, St. Gallen.
Edition of 78 / XXIV unique versions (design versions 1A–3A: 13 each on different colors;
diagonal design versions 1B–3B: 13 each on different colors),
stamped and numbered certificate, **$ 2500 / € 2300**
Special price for 3 tablecloths in 3 different designs **$ 6100 / € 5500**

UNIKAT-TISCHTUCH MIT LASERSPITZE (AUF TISCH ZU PLATZIERENDES OBJEKT), **2002** (PARKETT 66)

Weisses Tischtuch mit Laserschnittdesign und farbigem Untertischtuch.
Die Kombination von Muster und Farbe ist bei jedem Tischtuch anders. Grösse 180 x 180 cm;
Untertischtuch 170 x 170 cm; Muster 78 x 78 cm, Breite des Streifenelements 8,7 cm.
Polyester, waschbar, Laserschnitt und Herstellung: Jakob Schläpfer AG, St. Gallen.
Auflage: 78 / XXIV Unikate (Design-Versionen 1A–3A: je 13 auf verschiedenfarbigen Untertischtüchern;
diagonale Design-Versionen 1B–3B: je 13 auf verschiedenfarbigen Untertischtüchern), gestempeltes,
nummeriertes Zertifikat, **€ 2300 / CHF 2400**
Spezialpreis für 3 Tischtücher in 3 verschiedenen Designs **€ 5500 / CHF 5800**

RICHARD PHILLIPS

MISS PARKETT, 2004 (Parkett 71)

5-color lithograph on Somerset white paper,
paper size 26 x 20 ³/₁₆, image size 21 ¹/₄ x 16 ¹/₁₆".
Printed by Maurice Sanchez,
Derrière l'Étoile Studio, New York.
Edition of 70 / XXVI, signed and numbered.

Lithographie (5-farbig) auf Somerset-Papier,
Blattformat 66 x 51,3 cm, Bildformat 54 x 40,8
cm. Druck: Maurice Sanchez,
Derrière l'Étoile Studio, New York.
Auflage: 70 / XXVI, signiert und nummeriert.

$ 2100 / € 1800 / CHF 1900

LUC TUYMANS

SILENCE, 1990–2000 (Parkett 60)

Men's cotton shirt with reproduction of the artist's painting
SILENCE, 1991, shirt design by Walter van Beirendonck,
3 sizes (S, M, L), silkscreen version printed by Lorenz Boegli, Zurich,
Ed. 99/XXX, signed and numbered

STILLE, 1990–2000

Baumwoll-Herrenhemd mit Reproduktion des Bildes SILENCE, 1991,
Hemddesign Walter van Beirendonck, 3 Grössen (S, M, L),
Siebdruck Version gedruckt von Lorenz Boegli, Zürich,
Ed. 99/XXX, signiert und nummeriert

$ 1000 / € 800 / CHF 900

PIPILOTTI RIST

THE HELP, 2004 (Anniversary Edition Parkett 71)

Cut-out, 4-color print on fabric, ca. 70 $^7/_8$ x 43 $^5/_{16}$",
with 7 straight pins (plus 7 spare pins) to fasten
it to a wall, a chair, or a table.
Support: Thomas Rhyner; Photo by Martin Stollenwerk.
Printed by Plotfactory, Weisslingen, Switzerland.
Edition of 70 / XX, signed and numbered.

DIE HILFE, 2004 (Anniversary Edition Parkett 71)

Inkjet-Druck, 4-farbig auf Stoff, ca. 180 x 90 cm.
Wird mit 7 Stecknadeln (und 7 Ersatzstecknadeln)
geliefert und kann an der Wand oder auf einem
Stuhl oder Tisch platziert werden.
Mitarbeit: Thomas Rhyner; Photo: Martin Stollenwerk.
Druck: Plotfactory, Weisslingen.
Auflage: 70 / XX, signiert und nummeriert.

$ 3000 / € 2700 / CHF 2800

CARSTEN HÖLLER

KEY TO THE LABORATORY OF DOUBT, 2006
(Parkett 77)

Anamorphic key, cast in sterling silver,
approx. 3 $^1/_8$ x $^3/_4$ x $^1/_8$".
Silver plated steel cylinder, $^{11}/_2$ x $^3/_4$".
Silver necklace approx. 27 $^1/_2$".
Black box with embossed print.
Production and 3-D scanning by
Factum Arte, Madrid.
Edition of 50 / XXV, initials engraved
and numbered.

SCHLÜSSEL ZUM LABORATORIUM DES ZWEIFELS, 2006 (Parkett 77)

Anamorphischer Schlüssel, gegossen in Sterling-Silber, ca. 8 x 2 x 0,5 cm. Zylinder aus
versilbertem Edelstahl, 4 x 2 cm. Halskette aus Silber, ca. 70 cm. Schwarze Schachtel mit
Prägedruck. Produktion und 3-D-Scanning, Factum Arte, Madrid.
Auflage 50 / XXV, Initialen graviert und nummeriert.

$ 4100 / € 3700 / CHF 3800

OLAF NICOLAI

GEORG'S PILLOW, 2007 (Parkett 78)
(Replica of a pillow from Georg Lukács'
sofa bed in his study at Belgrad Kai,
Budapest)

Handwoven pillowcase, hand-dyed
sheep's wool and red silk, 18 $^1/_2$ x 20".
Made by the Department of Textiles,
Institute of Applied Arts,
Schneeberg, Germany.
Edition of 35 / XX, signed and numbered
certificate.

GEORGS KISSEN, 2007 (Parkett 78)
(Replik eines Kopfkissens von Georg Lukács' Schlafsofa aus seinem Arbeitszimmer
am Belgrad Kai in Budapest)

Handgewebter Kissenbezug, handgefärbte Schurwolle und rote Seide, 47 x 51 cm.
Manufaktur: Werkstatt Textilkunst der Fachhochschule für Angewandte Kunst,
Schneeberg, Deutschland.
Auflage 35 / XX, signiertes und nummeriertes Zertifikat.

$ 3800 / € 3400 / CHF 3500

LUCY McKENZIE

UNTITLED, 2006 (Parkett 76)

5-color silkscreen on Somerset Satin;
Paper size 29 $^1/_2$ x 22", image 22 $^1/_2$ x 15".
Printed by Bernie Reid, Edinburgh, Scotland.
Edition of 60 / XX, signed and numbered.

Siebdruck (5 Farben) auf Somerset Satin;
Papierformat 75 x 55,8 cm, Bild 57 x 38 cm.
Gedruckt bei Bernie Reid, Edinburgh, Scotland.
Auflage: 60 / XX, signiert und nummeriert.

$ 2100 / € 1800 / CHF 1900

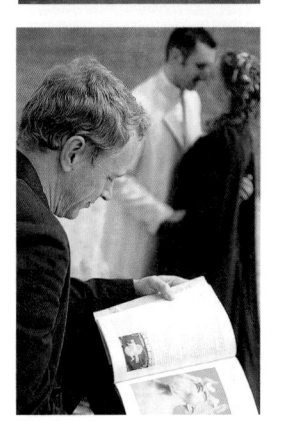

CHRISTIAN JANKOWSKI

CHRISTIAN JANKOWSKI READS 50 PARKETT ARTISTS COLLABORATIONS, 2007–2008 (Parkett 81)

50 unique photographs by 50 photographers, 9 $^3/_4$ x 7 $^3/_4$" each. Edition of 1/II, each signed and numbered.

CHRISTIAN JANKOWSKI LIEST TEXTE ZU 50 PARKETT COLLABORATION KÜNSTLERN, 2007–2008 (Parkett 81)

50 Unikat-Photographien von 50 Photographen, je 25 x 20 cm. Auflage: 1/II, je signiert und nummeriert.

$ 2700 / € 2400 / CHF 2500

Set of 3 unique photographs: **$ 6300 / € 5700**
Set von 3 Unikat-Photographien: **€ 5700 / CHF 6000**

JON KESSLER

HABEAS CORPUS, 2007 (Parkett 79)

Sculpture, opaque and transparent non-toxic urethane, instant urethane pigments, orange polyester satin fabric, cap, glasses, mask, ear muffs, sneakers, cable tie.
6 $^3/_4$ x 3 $^1/_2$ x 2 $^3/_4$", production by Gamla Model Makers, Feasterville, PA.
Edition of 60 / XX, signed and numbered certificate.

Skulptur, opakes und transparentes, nicht-toxisches Urethan, Urethan-Farbpigmente, oranger Polyester-Satin-Overall, Kappe, Brille, Maske, Ohrschutz, Turnschuhe, Fessel.
17 x 9 x 7 cm, Produktion: Gamla Model Makers, Feasterville, PA.
Auflage: 60 / XX, signiertes und nummeriertes Zertifikat.

$ 2600 / € 2300 / CHF 2400

RACHEL HARRISON

WARDROBE MALFUNCTION, 2008
(Parkett 82)

10-color lithograph on polypropylene,
26 $^3/_8$ x 18 $^3/_8$"
Printed by Derrière L'Etoile Studio, New York.
Edition of 48 / XXII, signed and numbered.

10-Farben-Lithographie auf Polypropylen,
67 x 46,8 cm
Gedruckt bei Derrière L'Etoile Studio, New York.
Auflage 48 / XXII, signiert und nummeriert.

$ 3000 / € 2700 / CHF 2800

COSIMA VON BONIN

COLOUR WHEEL, 2007 (Parkett 81)

Stainless steel, Polypropylen handles,
enameled in 7 colors, 18 $^1/_2$ x 2 $^1/_4$",
production by Saygel & Schreiber, Berlin.
Edition of 45 / XXV, signed and numbered
certificate.

Edelstahl, Griffe aus Polypropylen,
lackiert in 7 Farben, 47 x 6 cm,
Produktion: Saygel & Schreiber, Berlin.
Auflage 45 / XXV, signiertes und
nummeriertes Zertifikat.

$ 3100 / € 2700 / CHF 2800

MAI-THU PERRET WITH LIGIA DIAS

A PORTABLE APOCALYPSE BALLET (RED RING), 2008
(Parkett 84)

Sculpture, opaque non-toxic polyurethane resin, color cast with instant polyurethane pigments. Clothing designed by Ligia Dias, beige viscose fabric with white accents and metal buttons, black leather belt. Modacrylic light brown wig. Solid cast polyurethane resin base, painted. Neon ring powered by 12 V CE and UL approved universal wall adapter. 14 $^3/_4$ x 7 x 7", production by Gamla Model Makers, Feasterville, PA, USA.
Ed. 45/XX, signed and numbered certificate.

Skulptur, opakes, nicht-toxisches Polyurethan, gegossen mit Polyurethan-Farbpigmenten. Kleidung entworfen von Ligia Dias, beiges Viscosegewebe, weisse Bordüren, Metallknöpfe, schwarzer Ledergürtel, hellbraune Acryl-Perücke. Gegossener Polyurethan-Fuss, bemalt.
12-V-Neonring mit UL- und CE-Zeichen, mit Adapter.
37,5 x 17,8 x 17,8 cm, Produktion: Gamla Model Makers, Feasterville, PA.
Auflage: 45/XX, signiertes und nummeriertes Zertifikat.

$ 3000 / € 2700 / CHF 2800

TOMMA ABTS

UNTITLED (UTO), 2008 (Parkett 84)

Archival pigment print on Angelica paper, mounted on sintra, framed.
Paper size 15 $^7/_8$ x 19 $^3/_4$", image 15 x 18 $^7/_8$".
Printed by Laumont, New York.
Ed. 45/XXV, signed and numbered certificate.

Alterungsbeständiger Pigmentdruck auf Angelica-Papier, aufgezogen auf Sintra, gerahmt.
Papierformat 50,5 x 40,5 cm, Bild 48 x 38 cm.
Gedruckt bei Laumont, New York.
Auflage 45/XXV, signiertes und nummeriertes Zertifikat.

$ 3200 / € 2800 / CHF 2900

CERITH WYN EVANS

E=Q=U=A=L=S, 2010 (Parkett 87)

Neon light, 5 x 2 x $^3/_8$"(12 x 5 x 1 cm),
electrical power cable,
transformer 6 x $^7/_8$ x $^7/_8$" (15 x 2 x 2 cm),
with installation guide, production
by NEON Line, Vienna,
Ed. 35/XX, signed and numbered certificate

Neonlicht, 12 x 5 x 1 cm, elektrisches Kabel,
Transformer 15 x 2 x 2 cm,
mit Installationsanleitung,
Produktion: NEON Line, Wien.
Auflage 35/XX, signiertes und nummeriertes
Zertifikat

$ 3500 / € 3300 / CHF 3500

ZOE LEONARD

1 HOUR PHOTO & VIDEO, 2007/2008
(Parkett 84)

C-print, paper size 18 x 13", image: 8 $^1/_2$ x 8 $^1/_2$",
printed by My Own Color Lab, New York.
Ed. 45 / XXV, signed and numbered.

C-Print, Papierformat 45,7 x 33 cm,
Bild 21,6 x 21,6 cm,
gedruckt by My Own Color Lab, New York.
Auflage 45 / XXV, signiert und nummeriert.

$ 1900 / € 1700 / CHF 1800

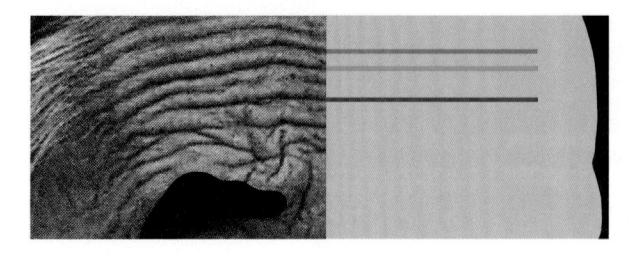

JOHN BALDESSARI

RAISED EYEBROWS / FURROWED FOREHEADS:
CROOKED MADE STRAIGHT, 2009 (Parkett 86)

9-color silkscreen print (front and back) on Plexiglas, 5 x 12 x ⅛".
Printed by Atelier für Siebdruck, Lorenz Boegli, Zurich.
Edition of 45/XX, signed and numbered certificate.

Siebdruck (9 Farben) beidseitig auf Plexiglas, 12,5 x 31 x 0,4 cm.
Druck: Atelier für Siebdruck Lorenz Bögli, Zürich.
Auflage 45/XX, signiertes und nummeriertes Zertifikat.

$ 2700 / € 2400 / CHF 2500

JEAN-LUC MYLAYNE

NO. PO-65, FACE TO FACE,
APRIL/MAY 2001 (Parkett 85)

C-print, transparency, image size: 9½ x 9½",
Mounted between Altuglass, 15 x 15 x 2¾", 16,5 lb,
with 2nd C-Print (diptych), 9½ x 23⅝"
(mounted behind plexi). Artist designed certificate
including a close-up photograph of the bird facing
the apple, 5½ x 5½".
Edition of 38/XXII, signed and numbered certificate

C-print, Diapositiv, Bildformat 24 x 24 cm,
Montiert zwischen Altuglas, 38 x 38 x 7 cm, 7,5 kg,
mit 2. C-Print (Diptych), 24,2 x 60 cm (hinter Plexi).
Vom Künstler gestaltetes Zertifikat mit einem
Ausschnitt der Photographie von Vogel und Apfel,
14 x 14 cm.
Auflage 38/XXII, signiertes und
nummeriertes Zertifikat.

$ 3800 / € 3500 / CHF 3600

PAUL CHAN

THE LIBERTINE READER, 2011 (Parkett 88)

Silkscreen on a natural woven rayon cloth,
with foil stamping,
on wooden frame, 25 x 16 $^1/_2$ x $^3/_4$".
Printed by Atelier für Siebdruck, Lorenz Boegli, Zurich
Ed. 35/XX, signed and numbered certificate

Siebdruck auf natürlich gewebtem Rayon-Leinen,
mit Folienprägung,
auf Holzrahmen, 63,5 x 42 x 1,9 cm.
Gedruckt bei Atelier für Siebdruck, Lorenz Boegli, Zürich.
Auflage 35/XX, signiertes und nummeriertes Zertifikat.

$ 3000 / € 2700 / CHF 2800

ANNETTE KELM

UNTITLED, 2010 (Parkett 87)

C-print from 4 x 5" negative,
on Fuji Crystal Archive DPII matt,
paper size 16 x 20 $^5/_8$",
image: 14 $^1/_2$ x 19 $^1/_8$",
printed by Golab, Berlin.
Edition of 38/XX,
signed and numbered certificate.

C-Print ab 4 x 5" Negativ,
auf Fuji Crystal Archive DPII matt,
Papierformat 40,5 cm x 52,4 cm,
Bild 36,7 cm x 48,6 cm,
gedruckt bei Golab, Berlin.
Auflage 38/XX,
signiertes und nummeriertes Zertifikat.

$ 2100 / € 1800 / CHF 1900

VERGRIFFENE EDITIONEN

EDITION FOR PARKETT 39

WOLFGANG LAIB

A Wax Room for a Mountain, 1994

Silkscreen, oilstick on Rivoli SK2 240 g/m²,
19 ½ x 16 ⅛" (49,2 x 40,9 cm),
printed by Atelier für Siebdruck,
Lorenz Boegli, Zurich,
Ed. 75/XL, signed and numbered

EDITION FOR PARKETT 76

YANG FUDONG

Ms. Huang at M.
Last Night, 2006

Black-and-white photograph, Lambda print on Kodak Endura paper,
paper size: 19 ½ x 29 ½" (50 x 75 cm), image: 18 ⅞ x 28 ¾" (48 x 73 cm),
Ed. 60/XX, signed and numbered certificate

OUT OF PRINT EDITIONS

EDITION FOR PARKETT 92

DAMIÁN ORTEGA

Parkett, 2013

Parquet floor, 12 painted,
unique segments,
to be arranged individually,
each segment of
5 loose pieces;
each segment
approx. 7 $1/2$ x 7 $1/2$ x $3/4$".
Ed. 35/XXX,
signed and numbered

EDITION FOR PARKETT 78

ERNESTO NETO

Phytuziann, 2006

Green lycra tulle and polypropylene pellets,
17 $3/4$ x 10 $3/4$ x 2" (45 x 27 x 5cm);
weight: 4 lb. (900 g),
Ed. 60/XX, signed and numbered

ANDRO WEKUA

BLACK SEA LAMP, 2011 (Parkett 88)

Color glass lamp with metal base,
conceived and designed by the artist,
glass colored and bent by glassworks GmbH,
casing cut from lacquered steel sheet,
illuminated with 2 LED bulbs, electrical cable,
fabricated and assembled
by Kunstbetrieb AG Münchenstein, Switzerland,
7 $\frac{1}{4}$ x 7 $\frac{1}{4}$ x 3 $\frac{1}{8}$".
Ed. 35/XX, signed and numbered certificate.

Lampe mit gefärbtem Glas und Metall-Fassung,
vom Künstler entworfen und gestaltet.
Gefärbtes und gewelltes Glas, hergestellt
von Glassworks GmbH, Gehäuse aus geschnittem
und lackiertem Stahlblech, 2 LED Glühbirnen,
Kabel, produziert und zusammengestellt
von Kunstbetrieb AG Münchenstein, Schweiz.
18,3 x 13,5 x 8 cm.
Auflage 35/XX, signiertes und
nummeriertes Zertifikat.

$ 3000 / € 2700 / CHF 2800

STURTEVANT

DIALOGUE OF THE DOGS, 2005 / 2011
(Parkett 88)

Animated film, 1 min. loop, on DVD,
with case, inserted in Parkett 88.
Ed 35/XX, with signed and numbered certificate

Animierter Film, 1 Min. Loop, auf DVD,
in Hülle, eingelegt in Parkett 88.
Auflage 35/XX, signiertes und
nummeriertes Zertifikat

$ 3000 / € 2700 / CHF 2800

PARASITE PATCH "Ö" PARASITE PATCH "Ä"

KERSTIN BRÄTSCH and DAS INSTITUT

PARASITE PATCH from Schröder*line* 2011 (Parkett 88)
NOTHING NOTHING / THUS / Ä / Ö

Knitted textile patch in 4 versions with 4 design layers,
made of custom dyed yarns, each layer: 15 x 12".
Designed by DAS INSTITUT (Kerstin Brätsch, Adele Röder).
Program and digital knitwear by Stoll, New York.
Cotton yarn by Filartex, Italy,
silk/merino yarn by Cariaggi and Filpucchi, Italy.
To be individually attached onto clothes
with three snap buttons.
The Parasite Patch can be worn displaying
each of the 4 different design layers.
Ed. 18/X for each patch version,
with signed and numbered certificate.

PARASITE PATCH "THUS"

PARASITE PATCH aus Schröder*line* 2011 (Parkett 88)
NOTHING NOTHING / THUS / Ä / Ö

Gestricktes Textilobjekt in 4 Versionen mit 4 Design Variationen,
hergestellt aus gefärbtem Garn,
jede Design Variation 38 x 30,5 cm.
Gestaltet von DAS INSTITUT (Kerstin Brätsch, Adele Röder).
Programm und digitale Umsetzung von Stoll, New York,
Baumwollgarne von Filartex, Italien,
Seiden- und Merinogarn von Cariaggi und Filpucchi, Italien.
Zur individuellen Befestigung auf Kleidungsstücken
mit drei Druckknöpfen. Der Parasite Patch kann mit jeder
der 4 Design Variationen getragen werden.
Auflage 18/X für jede Version,
mit signiertem und nummeriertem Zertifikat.

$ 3000 / € 2700 / CHF 2800

PARASITE PATCH "NOTHING NOTHING"

HAEGUE YANG

CUP COSIES, 2011 (Parkett 89)

Knitting yarn in varying colors
and patterns, each unique,
100 plastic cups, approx. 27" high,
diameter 4 $^1/_8$".
Ed. 35/XX, signed and
numbered certificate.

Strickgarn in verschiedenen Farben
und Mustern, Unikate,
100 Plastikbecher, ca. 70 cm hoch,
Durchmesser 10,5 cm.
Auflage 35/XX, signiertes und
nummeriertes Zertifikat.

$ 3200 / € 2800 / CHF 2900

CHARLINE VON HEYL

LACUNA LOTTO, 2011 (Parkett 89)

Monotype with lithograph collage,
each unique, paper: monotype,
Plike white 340 g/m^2;
lithograph, Plike 80 g/m^2, 27 $^1/_2$ x 18 $^7/_8$",
printed in 2 colors and assembled by
Derrière L'Etoile Studio, New York.
40 arabic numbered and signed works,
20 roman numbered and signed artist's proofs,
5 numbered and signed printer proofs.

Monotypie mit lithographierter Collage, Unikate, Papier: Monotypie, Plike weiss 340g/m^2;
Lithographie, Plike 80 g/m^2, 68,5 x 48 cm, gedruckt in 2 Farben und zusammengefügt von
Derrière L'Etoile Studio, New York.
40 arabisch nummerierte und signierte Arbeiten, 20 römisch nummerierte und signierte
Künstlerexemplare, 5 nummerierte und signierte Druckerexemplare.

$ 3200 / € 2800 / CHF 2900

 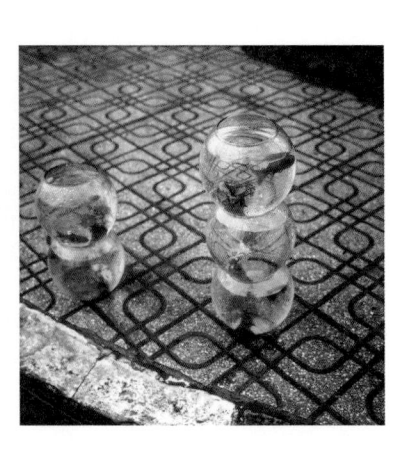

YTO BARRADA

AQUARIUMS FOR SALE ON A RAINY DAY, TANGIER 2001 (Parkett 91)

Two C-Prints, 10 1/4 x 11" each.
Ed. 35/XX, signed and numbered certificate.

Zwei C-Prints, je 26 x 28 cm.
Auflage 35/XX, signiertes und nummeriertes Zertifikat.

$ 2400 / € 2100 / CHF 2200

MONIKA SOSNOWSKA

FLY REPELLENT, 2012 (Parkett 91)

Two plastic bags, wire, electric motor,
cable, 23 1/2" in diameter,
minimal distance to ceiling 13 3/4".
Ed. 35/XX, signed and
numbered certificate.

Zwei Plastiktüten, Draht, Elektromotor,
Kabel, Durchmesser 60 cm,
minimaler Abstand zur Decke, 35 cm.
Auflage 35/XX, signiertes und
nummeriertes Zertifkat.

$ 2800 / € 2500 / CHF 2600

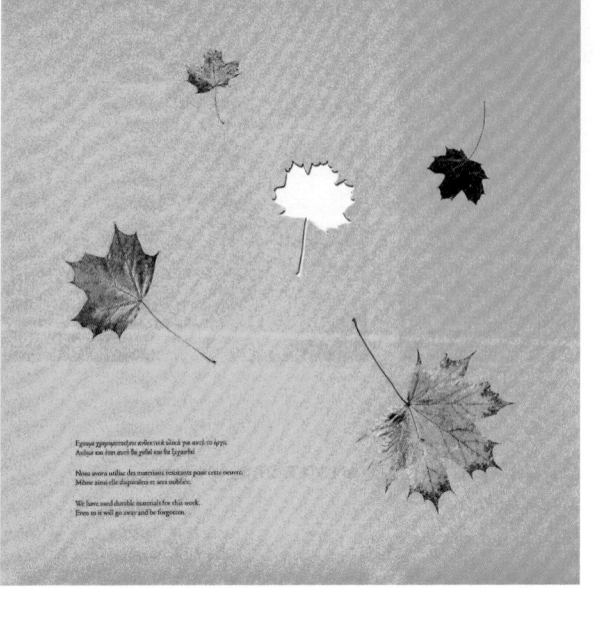

JIMMIE DURHAM

LOOK AHEAD, 2013 (Parkett 92)

9 color silkscreen print,
on Arches Velin 400 g/m²,
one leaf lasercut, 31 ¹/₂ x 31 ¹/₂".
Printed by Atelier für
Siebdruck, Lorenz Boegli.
Ed. 35 / XX,
signed and numbered.

9-Farben Siebdruck,
auf Arches Velin 400 g/m²,
ein Blatt mit Laser ausgeschnitten,
80 x 80 cm.
Gedruckt von Atelier für
Siebdruck, Lorenz Boegli.
Auflage 35 / XX,
signiert und nummeriert.

$ 2500 / € 2200 / CHF 2300

NICOLE EISENMAN

UNTITLED, 2012 (Parkett 91)

Color monotypes, each unique, 24 ¹/₄ x 18 ³/₄".
Ed. 15 / VI, signed and numbered.

Farbmonotypien, Unikate, 61,6 x 47,6 cm.
Auflage 15 / VI, signiert und nummeriert.

$ 4800 / € 4300 / CHF 4400

FRANCES STARK

DISHONEST BUT APPEALING, 2013
(Parkett 93)

Book with safe, paper pages, hand bound, hardcover with embossed printing, red cloth, silk ribbon, 11 $^1/_2$ x 8 $^1/_2$ x 2 $^1/_4$ ".
Edition of 35/XX, signed and numbered.

Buch mit Geheimfach, Papierseiten, handgebunden, Buchdeckel mit Goldprägung, roter Stoff, Seidenband. 28,5 x 21,5 x 6 cm.
Auflage 35/XX, signiert und nummeriert.

$ 2000 / € 1700 / CHF 1800

VALENTIN CARRON

BELL, 2013 (Parkett 93)

Bronze cast, wood, diameter 6 $^1/_2$ x 2 $^3/_4$ ", fabricated by Kunstbetrieb AG, Münchenstein, Switzerland.
Ed. 35/XX, signed and numbered certificate.

Bronzeguss, schwarz patiniert, Holz, Durchmesser 16 x 7 cm.
Produziert bei Kunstbetrieb AG, Münchenstein, Schweiz.
Auflage 35/XX, signiertes und nummeriertes Zertifikat.

$ 2600 / € 2300 / CHF 2400

SHIRANA SHAHBAZI

COMPOSITION WITH MOUNTAIN, 2014
(Parkett 94)

6-color lithograph on gelatin silver baryta print.
22 $^3/_8$ x 18 $^1/_8$", printed by
Steindruckerei Wolfensberger, Zürich
and Tricolor Photoprint, Zürich
Ed. 35/XX, signed and numbered.

KOMPOSITION MIT BERG, 2014 (Parkett 94)
6-Farben-Lithographie auf Silbergelatin-Barytabzug.
56 x 46 cm, gedruckt bei
Steindruckerei Wolfensberger, Zürich
und Tricolor Photoprint, Zürich
Auflage 35/XX, signiert und nummeriert.

$ 2900 / € 2600 / CHF 2700

JEREMY DELLER

ODDS AND SODS, 2001–2014 (Parkett 95)

Portfolio with 5 silkscreen prints in 6 colors,
BVK Rives 300 g/m², each approx. 17 $^3/_4$ x 11 $^3/_4$":
BATS, 2011;
BARN OWL, 2013 (from ENGLISH MAGIC);
THE BATTLE OF ORGREAVE, 2001;
MORE POETRY IS NEEDED, Swansea, 2014;
SACRILEGE, 2012;
Atelier für Siebdruck, Lorenz Boegli.
Ed. 35/XX, signed and numbered colophon.

$ 2900 / € 2700 / CHF 2800

Portfolio mit 5 Siebdrucken in 6 Farben,
BVK Rives 300 g/m², je ca. 45x30 cm:
BATS, 2011;
BARN OWL, 2013 (aus ENGLISH MAGIC);
THE BATTLE OF ORGREAVE, 2001;
MORE POETRY IS NEEDED; Swansea, 2014;
SACRILEGE, 2012;
Atelier für Siebdruck, Lorenz Boegli.
Auflage 35/XX, signiertes und
nummeriertes Kolophon.

DAYANITA SINGH

DEAR MR WALTER –
MONA AND MYSELF, 2014 (Parkett 95)

Archival pigment print on Harmon-Hahnemühle
baryta paper, mounted on archival museum board,
18 x 24", teak wood frame, with a removable matt
revealing four images:
MONA AND MYSELF, 2013,
PHEROZA VAKEEL from *Privacy*, 2003,
UNTITLED from *I am as I am*, 2000,
UNTITLED from *Go Away Closer*, 2007.
Ed. 35/XX, signed, numbered and titled on back.

Alterungsbeständiger Pigment-Abzug auf
Harmon-Hahnemühle Barytpapier,
aufgezogen auf Museumskarton, 46 x 61 cm,
Teakholz-Rahmen, mit einem aufklappbaren
Passepartout, der vier Bilder hervorhebt:
MONA AND MYSELF, 2013,
PHEROZA VAKEEL aus *Privacy*, 2003,
UNTITLED aus *I am as I am*, 2000,
UNTITLED aus *Go Away Closer*, 2007.
Auflage 35/XX, signiert, nummeriert und
betitelt auf der Rückseite.

$ 2900 / € 2700 / CHF 2800

CYPRIEN GAILLARD

AN URGENT MESSAGE ABOUT
THE GREAT ORGAN, 2014 (Parkett 94)

Aluminum sculpture with 7-color silkscreen print,
8 7/8 x 4 x 14 1/8",
printed by Atelier für Siebdruck, Lorenz Boegli.
Ed. 35/XX, signed and numbered certificate.

Aluminium-Skulptur mit 7-Farben-Siebdruck.
22,5 x 10 x 36 cm,
gedruckt von Atelier für Siebdruck, Lorenz Boegli.
Auflage 35/XX, signiertes und
nummeriertes Zertifikat.

$ 3300 / € 2800 / CHF 2900

PAMELA ROSENKRANZ

SURVIVOR SERIES, 2015 (Parkett 96)

Polyurethane resin, tinted,
15 3/4 x 3 x 1 1/2",
produced by Kunstbetrieb AG.
Ed. 35/XX, signed and numbered certificate.

Polyurethan-Giessharz, gefärbt,
40,2 x 7,8 x 3,7 cm,
produziert von Kunstbetrieb AG.
Auflage 35/XX, signiertes und
nummeriertes Zertifikat.

$ 2800 / € 2500 / CHF 2600

WAEL SHAWKY

UNTITLED, 2014 (Parkett 95)

Portfolio with 12 silkscreen prints in 1–6 colors,
BFK Rives 250 g/m², each 8 1/4 x 11 1/2"
Atelier für Siebdruck, Lorenz Boegli.
Ed. 35/XXV, signed and numbered colophon.

Portfolio mit 12 Siebdrucken in 1–6 Farben,
BFK Rives 250 g/m², je 21 x 29.7 cm.
Atelier für Siebdruck, Lorenz Boegli.
Auflage 35/XXV, signiertes und nummeriertes
Kolophon.

$ 2900 / € 2700 / CHF 2800

Portfolio no. 1–12 each come
with an additional original drawing.
Portfolio Nr. 1–12 enthalten
zusätzlich je eine Originalzeichnung.

$ 7900 / € 7300 / CHF 7700

1 of 12 silkscreen prints.

JOHN WATERS

«TRAGEDY», 2015 (Parkett 96)

Acrylic, synthetic hair,
painted silicon, urethane,
approx. 18 x 18 x 5",
produced by Alterian Inc.
Ed. 25/XX,
signed and numbered certificate.

Acryl, künstliches Haar,
bemaltes Silikon, Urethan,
ca. 46 x 46 x 12,5 cm,
produziert von Alterian Inc.
Auflage 25/XX,
signiertes und nummeriertes Zertifikat.

$ 6600 / € 6000 / CHF 6300

MARC CAMILLE CHAIMOWICZ

LOXOS, VASE, 1989/2015 (Parkett 96)

Crystal glass on aluminum base,
6³/₄ x 5¹/₂ x 3",
produced by Kunstbetrieb AG.
Ed. 35/XX, signed and numbered certificate.

Kristallglas in Aluminiumfassung,
17 x 14 x 7,8 cm,
produziert von Kunstbetrieb AG.
Auflage 35/XX, signiertes und
nummeriertes Zertifikat.

$ 2900 / € 2700 / CHF 2800

ABRAHAM CRUZVILLEGAS

AUTOCONCLUSIÓN, 2015 (Parkett 97)

Wooden briefcase, with 34 bamboo wood sticks in 34 different colors, with a separate 7-color silkscreen included in the briefcase, briefcase interior lined with canvas, briefcase custom made from larch wood and MDF by Stiftung St. Jakob, 13 1/8 x 21 x 1 3/4", 7,2 lb, silkscreen printed by Atelier für Siebdruck, Lorenz Boegli on Bütten 250 g/m² paper, 12 x 19 1/2". Ed. 35/XX, signed and numbered certificate.

Holzkoffer, mit 34 Stäbchen aus Bambusholz in 34 Farben, mit einem separaten Siebdruck in 7 Farben dem Koffer beiliegend, Kofferdeckel innen mit Leinwand bezogen, Koffer hand-gemacht aus Lärchenholz und MDF von Stiftung St. Jakob, 33,5 x 53,5 x 4,5 cm, 3,5 kg, Siebdruck von Atelier für Siebdruck, Lorenz Boegli auf Bütten 250 g/m², 30,5 x 50 cm. Auflage 35/XX, signiertes und nummeriertes Zertifikat.

$ 3300 / € 2900 / CHF 3300

ANDREA BÜTTNER

PIANO STOOL / KLAVIERSTUHL (Silkscreen), 2015
(Parkett 97)

Silkscreen in 4 colors, on 160 g/m² Fabriano Design 5, 24 x 25 1/8", printed by Atelier für Siebdruck, Lorenz Boegli. Ed. 25/XX, signed and numbered.

Siebdruck in 4 Farben, auf 160 g/m² Fabriano Design 5, 47,5 x 62,5 cm, gedruckt von Atelier für Siebdruck, Lorenz Boegli. Auflage 25/XX, signiert und nummeriert.

$ 1800 / € 1600 / CHF 1800

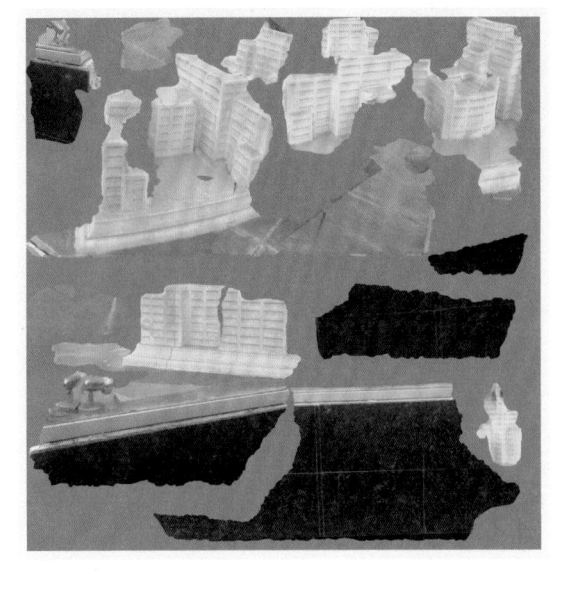

HITO STEYERL

GOSPROM, 2015 (Parkett 97)

Silkscreen in 7 colors,
on Invercote G 380 g/m², 27 ½ x 27 ½",
printed by Atelier für
Siebdruck, Lorenz Boegli.
Ed. 35/XX, signed and numbered.

Siebdruck in 7 Farben,
auf Invercote G 380 g/m², 70 x 70 cm,
gedruckt von Atelier für
Siebdruck, Lorenz Boegli.
Auflage 35/XX, signiert und nummeriert.

$ 1800 / € 1600 / CHF 1800

CAMILLE HENROT

EXTINCTION ON THE TABLE, 2015 (Parkett 97)

Two UV prints one on each side of a sheet
of white nitrile rubber, (the work can be
installed either flat or loosely and carefully
draped on the wall, a table or the floor),
with two grommets.
Printed by Laumont, New York,
22 x 30 x ⅛", ca. 6lb,
Ed. 35/XX, signed and numbered.

Zwei UV-Drucke auf beiden Seiten eines
weissen Nitrilkautschuk Bogens, (das Werk
kann entweder flach oder sorgfältig gerollt
installiert werden, an einer Wand, auf einem
Tisch, oder am Boden), mit zwei Ösen,
gedruckt bei Laumont, New York,
55 x 75 x 0.35 cm, ca. 3kg,
Auflage 35/XX, signiert und nummeriert.

$ 2800 / € 2500 / CHF 2800

THEASTER GATES

SOUL BOWL, 2016 (Parkett 98)

Stoneware with glaze, two bowls,
one in black and one in white, each
unique, diameter 4–5", height 3–3 $^1/_2$",
weight ca. 1,2 lbs. each.
Packed in box with Association of
Named Negro American Potters
(A.N.N.A.P.) Logo.
Ed. 15 / X, signed and numbered
certificate.

Tonschalen, glasiert, je eine in
schwarz und weiss, Einzelstücke,
Durchmesser 10–13 cm,
Höhe 7–9 cm,
Gewicht ca. je 550g. Verpackt in
Schachtel mit dem Association
of Named Negro American Potters
(A.N.N.A.P.) Logo.
Auflage 15 / X, signiertes und
nummeriertes Zertifikat.

$ 2800 / € 2500 / CHF 2800

MIKA ROTTENBERG

BUBBLE 1 – BUBBLE 6 (Parkett 98)

Single channel video in six versions,
with sound, approx 15–40 sec. loop.
Custom-made purse in oyster design
(plastic, silk lining, zipper, $4\,^3/_4$ x $2\,^3/_8$ x $^1/_2$"),
with pearlescent capsule inside
containing memory stick.
Video to be presented on videomonitor.
Each video version
Ed. 6/2APs signed and numbered certificate.

1-Kanal-Video in sechs Versionen, Ton,
ca. 15–40 Sek., Loop.
Täschchen in Austern-Design
(Plastik, Seidenfutter, Reisverschluss,
12 x 6 x 1 cm), perlmutterbeschichtete
Kapsel mit Speicherstick.
Video zu betrachten auf Videomonitor.
Jede Video-Version Auflage 6/2 E.A.,
signiertes und nummeriertes Zertifikat.

$ 1900 / € 1700 / CHF 1900

LEE KIT

UPON, 2016 (Parkett 98)

Installation with photograph (archival print, framed) and towel.
Photograph, 7 ³/₄ x 9 ³/₄ ", overall dimensions variable.
Ed. 35/XX, signed and numbered certificate.

Installation mit Photographie (alterungsbeständiger Print,
gerahmt) und Handtuch.
Photographie 20 x 25 cm, Gesamtmasse variabel.
Auflage 35/XX, signiertes und nummeriertes Zertifikat.

$ 1900 / € 1700 / CHF 1900

ED ATKINS

SAFE CONDUCT EPIDERMAL, 2016 (Parkett 98)

Archival pigment print on rubber,
23 ⁵/₈ x 20 x ¹/₈", two grommets, printed by Laumont, New York.
Ed. 35/XX, signed and numbered certificate.

Alterungsbeständiger Pigmentdruck auf Gummi,
60 x 51 x 0,1 cm, zwei Ösen, gedruckt von Laumont, New York.
Auflage 35/XX, signiertes und nummeriertes Zertifikat.

$ 1900 / € 1700 / CHF 1900

PARKETT SPACE ZURICH

PARKETT SPACE ZURICH
Limmatstrasse 268
CH-8005 Zürich
Tel. Nr. +41-44-271 8140 /
500 3864

For exhibition pictures
and upcoming programs
please go to
parkettart.com / zurich-
exhibition-space

CARTE BLANCHE
by Pamela Rosenkranz
(Aug 2015 – March 2016)

Parkett collaboration artist Pamela Rosenkranz curates a selection of some 50 Parkett Editions and shares an insight into her artistic approach.

«CRUSH»
by Kilian Rüthemann
(Feb – July 2015)

An extraordinary presentation and sensurround experience of selected Parkett Editions with over ten tons of turquoise-colored, crushed glass on the gallery floor and pedestals made of large glass chunks.

PEOPLE
(Feb – July, 2013)

The show explored the exhibition theme and illustrated with sixty works the innovation and diversity, that artists bring to their Parkett projects in manyfold variations.

CORNUCOPIA
(Aug – Dec 2014)

On the occasion of Parkett's 30 years all editions were presented for the first time together in one room in a special display at the Zurich exhibition space.

ABSTRACT —NATURE
(Sep – Dec 2013)

A playful dialogue among fifty selected Parkett works with unexpected, often enlightening relations.

SMALL IS BEAUTIFUL
(Feb – June 2014)

A never before seen selection of some seventy works from the past thirty years, that all embody one of Parkett's key feature.

IDEAS, VARIATIONS & UNIQUE WORKS
(Oct 2012 – Jan 2013)

Forty groups of works documented the range of imagination and uniqueness that artists bring to their Parkett projects in untold variations.

Liebe Abonnentin, lieber Abonnent, liebe Leser,

Wir freuen uns, Ihnen diesen neuesten Überblick über die zurzeit erhältlichen Künstler-editionen zu präsentieren.

Die von Künstlerinnen und Künstlern eigens für Parkett geschaffenen Editionen, Graphiken, Objekte, Photographien – werden gegenwärtig in verschiedenen Museen gezeigt. Nach den kürzlichen Ausstellungen im Kanazawa Museum, Japan, in Singapur (STPI), im Seoul Arts Center-Hangaram Museum, Korea, in Beijing (UCCA) und in Taipeh (TFAM) reist die Ausstellung an weitere Orte. Frühere Präsentationen fanden u.a. im Museum of Modern Art, New York, in der Whitechapel Art Gallery, London, im Kunsthaus Zürich, und an anderen Orten statt.

Der Werkkatalog «200 Artworks – 25 Years» dokumentiert die Werke mit ganzseitigen Farbabbildungen, zwei Essays u.a.m. Weitere Informationen dazu finden Sie auf S. 23.

Für Fragen steht Ihnen Beatrice Fässler in Zürich (b.faessler@parkettart.com) jederzeit gerne zur Verfügung. Wir helfen Ihnen auch gerne bei der Suche nach vergriffenen Editionen. Ihre Bestellung können Sie uns online, per Telefon, Fax oder Post zukommen lassen (siehe auch den Antwortschein auf S. 35). Preisänderungen bleiben vorbehalten. Versand, Verpackungskosten und MwSt. sind nicht inbegriffen. Die Lieferung erfolgt in der Reihenfolge des Bestelleinganges solange Vorrat. Weitere Informationen finden Sie natürlich auch auf www.parkettart.com.

Mit freundlichen Grüssen

Dieter von Graffenried
Verleger

Bice Curiger
Chefredakteurin

PS
Für die alphabetische und chronologische Übersicht aller Künstler bzw. Parkett-Bände siehe ganz hinten S. 26 bzw. S. 28.

"200 Art Works – 25 Years"
Catalogue raisonné,
Parkett Artists' Editions

Cover:
Lee Kit
Edition for Parkett 98

"Commissioned by Parkett, ... the most important artists of our time have created works that represent the essence of their art or reveal an unexpected dimension."

Iwona Blazewick, Director, The Whitechapel Art Gallery, London

Dear Parkett Subscriber, dear Reader,

We are delighted to present to you this latest survey of all available artists'editions.

All works, prints, photographs, and objects made by the artists especially for Parkett are currently exhibited in the travelling retrospective. After the Kanazawa Museum in Japan, the exhibition traveled to Singapore (STPI), the Seoul Arts Center-Hangaram Museum in Korea to Beijing (UCCA) and most recently to Taipei (TFAM). Previous shows were held at the Museum of Modern Art, New York, the Whitechapel Art Gallery, London, the Centre Pompidou, Paris, and at other venues around the world.

The artists' editions are fully documented in the catalogue raisonné "200 Artworks – 25 Years", which features full page color illustrations of all works, two essays and more (see p. 23).

For any questions please contact Beatrice Fässler in Zurich (b.faessler@parkettart. com) or Melissa Burgos in New York (m.burgos@parkettart.com). We will also gladly help you find out-of-print editions. You are welcome to place orders online as well as by phone, fax or mail (see order form p. 35). Prices are subject to change, postage, packing and VAT are not included; orders will be filled on a first-come first-served basis. For more information visit www.parkettart.com.

Yours sincerely

Dieter von Graffenried
Publisher

Bice Curiger
Editor-in-Chief

PS
For alphabetical and chronological lists of all artists and Parkett
volumes see at the back p. 26 resp. p. 28.

Parkett Verlag
Quellenstrasse 27
CH-8031 Zürich
phone +41-44-271 8140
fax +41-44-272 4301

Parkett Publishers
145 Ave. of the Americas
New York, NY 10013
phone (212) 673 2660
fax (212) 271 0704

www.parkettart.com
info@parkettart.com

A SMALL MUSEUM AND A LARGE LIBRARY
ON CONTEMPORARY ART

PARKETT ARTISTS' EDITIONS

PARKETT